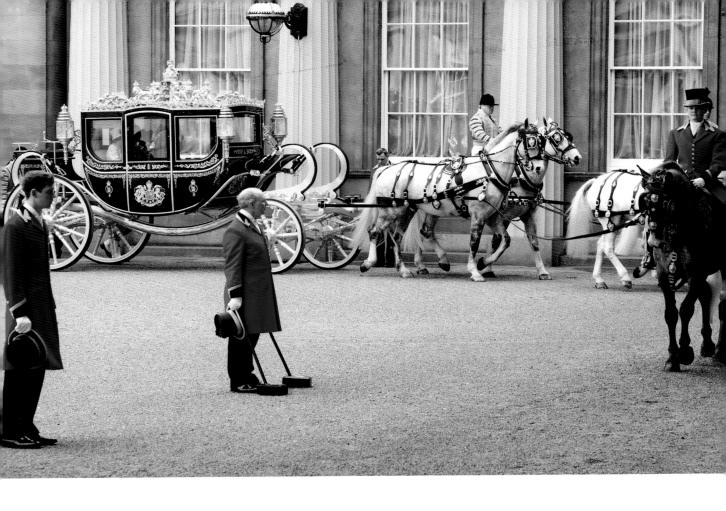

A ROYAL WELCOME

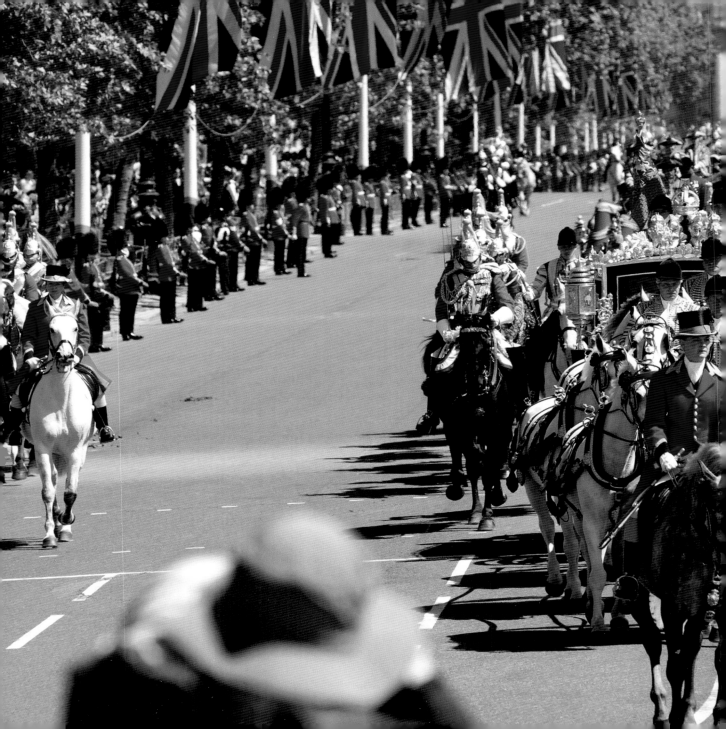

A ROYAL WELCOME

Making magnificence at Buckingham Palace

ANNA REYNOLDS

ROYAL COLLECTION TRUST

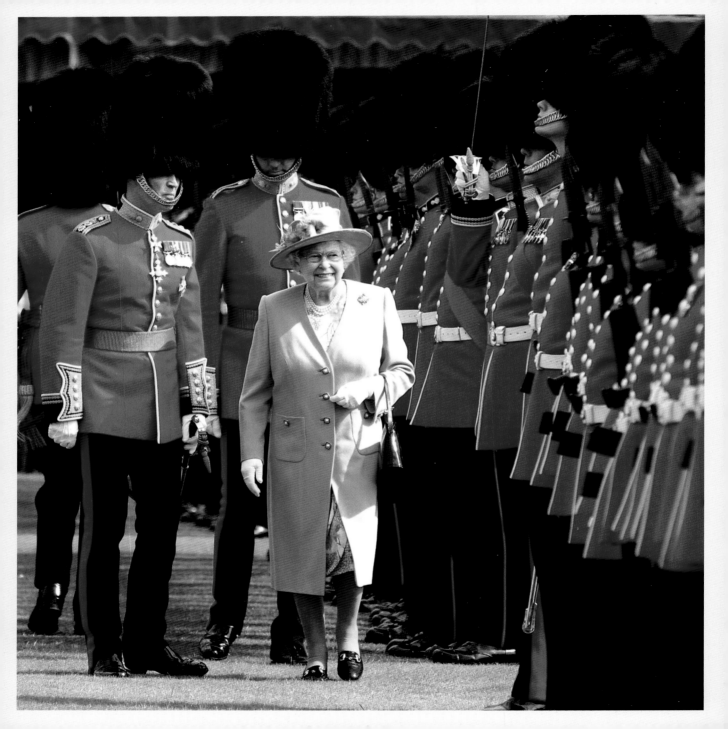

CONTENTS

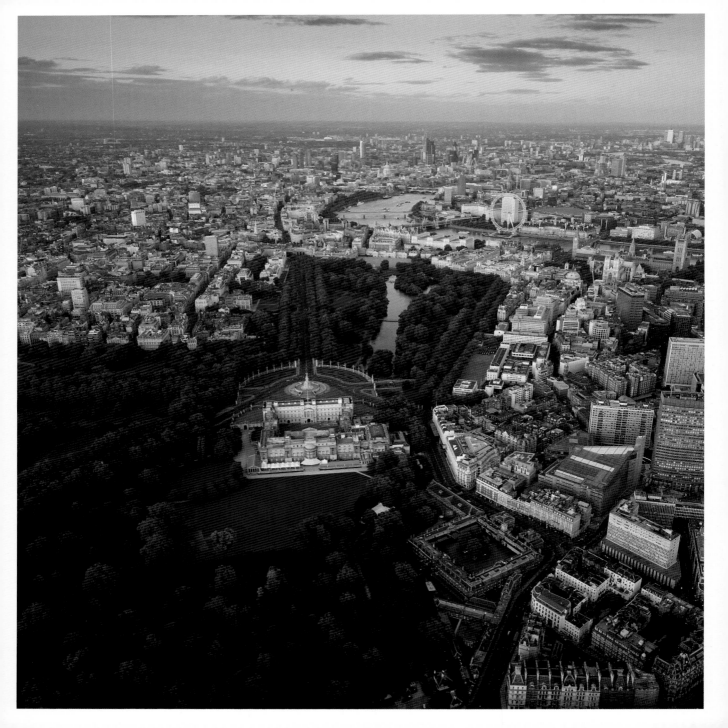

A ROYAL WELCOME

IN 2014 HER MAJESTY The Queen and other members of the Royal Family welcomed over 62,000 people as their guests to Buckingham Palace. From private one-to-one audiences with The Queen to the summer garden parties for up to 24,000 people in total, every year the State Rooms at Buckingham Palace are the venue for the Monarch to receive, reward and entertain people from a wide variety of nationalities and backgrounds. Guests to Buckingham Palace frequently remark on the impression made by the historic building and the extraordinary works of art and paintings within its magnificent rooms. Yet just as frequently they mention the warm and personal reception provided by members of the Royal Family, as well as Royal Household staff, whose role it is to make each guest feel comfortable and welcome.

Two State Visits each year help strengthen international relations, while Investitures recognise an individuals' accomplishments across all fields. Garden parties allow the Palace and gardens to be enjoyed by thousands of guests at once and private audiences allow diplomats and government ministers to meet with the Monarch. Each year a variety of receptions are held, with guests drawn each time from a particular area of our national life. Many of these occasions were first established in the nineteenth century – Queen Victoria first held garden parties at Buckingham Palace in the 1860s and introduced the Victoria Cross for valour in 1856 after the Crimean War, which is still awarded at Investitures today. However, while bound up with a sense of tradition that makes them entirely unique, over the years these occasions have evolved into a meritocratic means for people from all walks of life

OPPOSITE *Aerial view of Buckingham Palace and its gardens*

ABOVE RIGHT *Guests being welcomed at the Diplomatic Reception in 2014*

BELOW RIGHT *Guests in the Picture Gallery during the Diplomatic Reception*

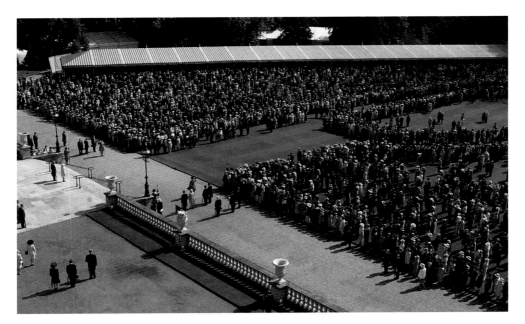

OPPOSITE *Architectural plan of of Buckingham Palace showing the location of the State Rooms*

to be rewarded and recognised for public service. Garden parties, for example, provide an opportunity for The Queen to meet a huge variety of people from very different communities, each of who is nominated from a large number of national and local organisations.

ENTERTAINING AT BUCKINGHAM PALACE

The Palace was designed with distinct public and private areas. The main entertaining rooms are the State Rooms on two floors of the western wing, while much of the rest of the Palace is filled with offices and workrooms. Buckingham House (as it was then known) was purchased by George III in 1761 who used the building primarily as a domestic retreat, with court functions

ABOVE *The Queen and The Duke of Edinburgh arriving on the West Terrace of Buckingham Palace during a garden party*

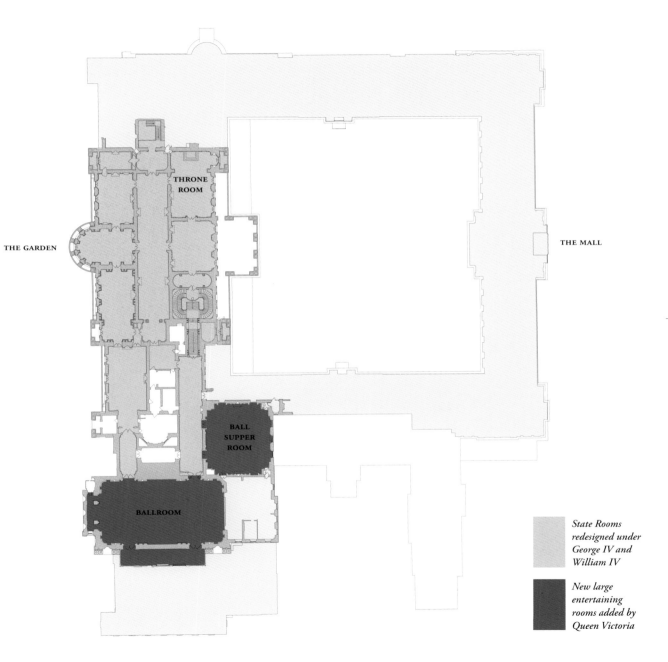

THRONE ROOM

THE GARDEN

THE MALL

BALL SUPPER ROOM

BALLROOM

State Rooms redesigned under George IV and William IV

New large entertaining rooms added by Queen Victoria

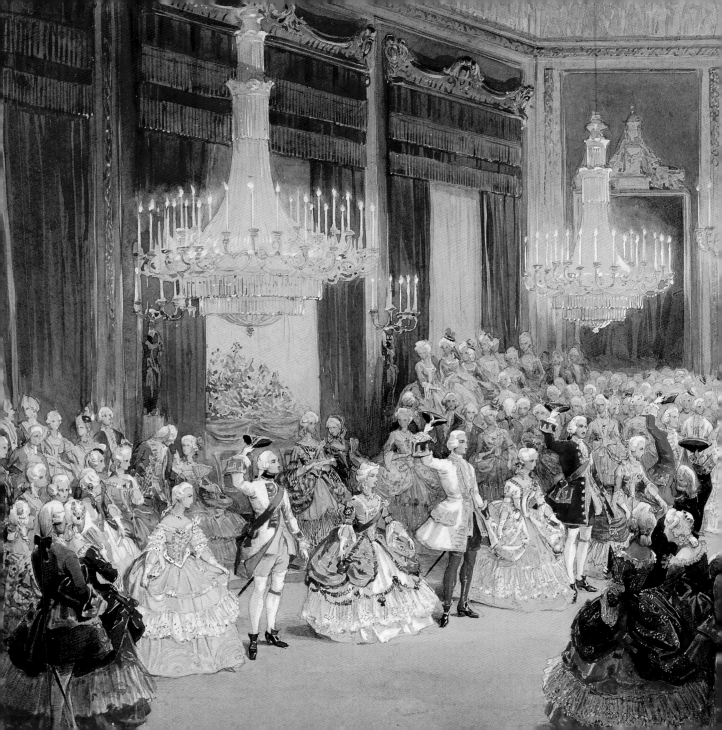

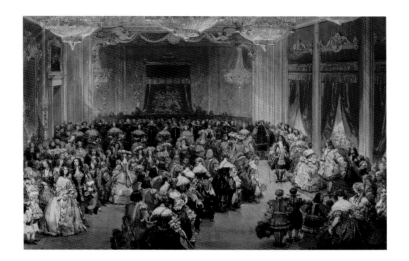

ABOVE *The Stuart Ball at Buckingham Palace held on 13 June 1851*

LEFT *The 1745 Fancy Ball at Buckingham Palace held on 6 June 1845, showing the royal set dancing in the Throne Room*

taking place at St James's Palace across the park. The first Monarch to entertain on a significant scale at Buckingham Palace was Queen Victoria who, after her accession in 1837, hosted three large-scale costume balls with her husband Prince Albert. The first, in 1842, was the Plantagenet Ball, when Queen Victoria dressed as Philippa of Hainault and Prince Albert as Edward III, founder of the Order of the Garter. These were followed by the Georgian *bal costumé* in 1845 for 1,500 guests and the Stuart Ball of 1851. As Louis Haghe's watercolours show, during the 1840s and 1850s the Throne Room was used for dancing, while the Picture Gallery was used for 'sitting out'. Supper was generally served in the State Dining Room, although larger events such as the banquet held for Prince Leopold's christening in 1853 were held in the Picture Gallery.

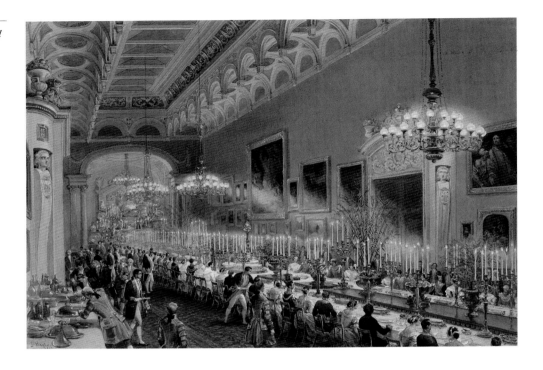

RIGHT *The banquet held in the Picture Gallery to commemorate the christening of Prince Leopold in 1853 by Louis Haghe*

At this event abundant pot plants and foliage from the gardens at Frogmore provided the floral decorations, while gold plate commissioned by George IV was used both to serve the food and to decorate buffet stands around the sides of the room. The invitation list for court balls in the nineteenth century generally included members of the British and other European royal families, the nobility, members of the diplomatic corps and politicians. More official visits by foreign Heads of State were also hosted – although the State Visit in its current format is a twentieth century innovation. In 1855 Napoleon III of France was entertained at Buckingham Palace. Queen Victoria described the occasion in her diary:

We dined at ¼ to 8, in the usual Dining Room, with all our suites, – the Emperor, Albert, & all the Gentlemen in uniform. The Empress was in white with emerald & diamond diadem & jewels, – I, in blue & gold, with a diamond diadem & my large Indian Rubies.

During the 1840s it became increasingly apparent to Queen Victoria and Prince Albert that Buckingham Palace was insufficient in size, both for their growing young family and for the social occasions that formed such a key component of nineteenth-century court life. In 1845 Queen Victoria wrote to the Prime Minister pointing out that, in addition

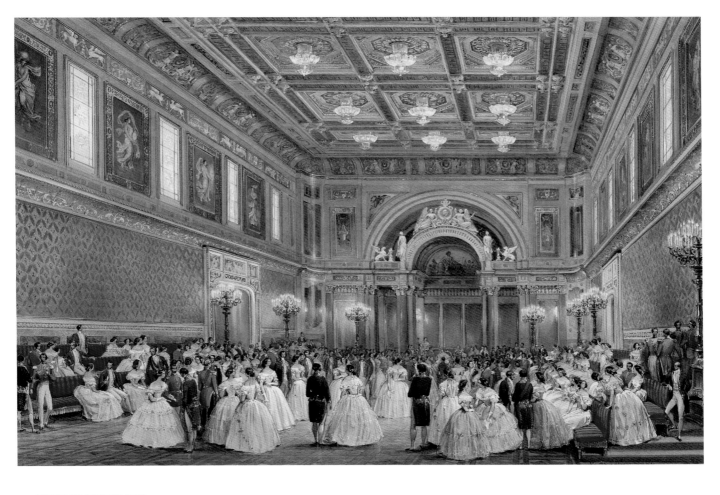

to new family accommodation, 'A room capable of containing a larger number of persons whom the Queen has to invite in the course of the season to balls, concerts etc is much wanted.' The architect James Pennethorne was subsequently commissioned to add two large-scale entertaining rooms – the Ball Supper Room and the Ballroom – onto the southern end of the State Apartments, which were accessed by a new East Gallery leading off the Grand Staircase. The new Ballroom was opened in 1856 with a ball to celebrate the end of the Crimean War. Measuring 37.5 metres long by 18.3 metres wide and 13.7 metres high, this room was one of the largest in London and allowed entertaining on a more lavish scale than ever before. The original brightly coloured interior decoration was replaced with a red, white and gold decorative scheme in the early year of the twentieth century, and this remains today.

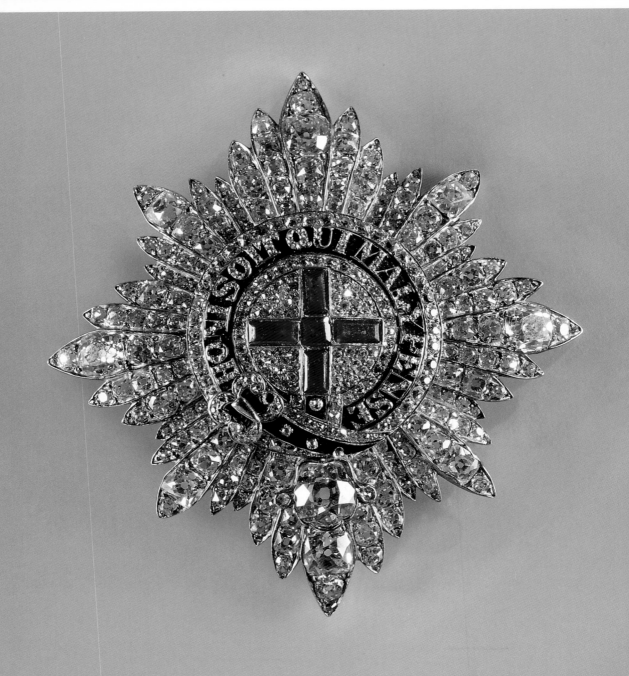

INVESTITURES

AN INVESTITURE IS A special occasion when those who have been awarded an honour receives their Insignia, in person from The Queen or another member of the Royal Family. Approximately 20 Investitures are hosted each year, the majority of which are held in the Ballroom at Buckingham Palace, although others take place in the Waterloo Chamber at Windsor Castle, or in the Great Gallery at the Palace of Holyroodhouse. The British honours system recognises outstanding achievements, personal bravery and service to the United Kingdom and the British Overseas Territories. Until the beginning of the nineteenth century, appointment to the Orders of Chivalry in England was restricted to the aristocracy and high-ranking military figures. Over time, people from a wider range of backgrounds were rewarded and for the last 20 years any member of the public has been able to nominate someone for an honour. Recipients of honours are announced each year on New Year's Day in the New Year Honours list and the Birthday Honours list on The Queen's official birthday on a Saturday in June. If The Queen is unable to conduct an Investiture she is represented by The Prince of Wales or another member of the Royal Family. While the Sovereign remains the 'fount of honour', and is responsible for awarding honours during Investitures, he or she is not personally responsible for choosing who should receive an honour. Instead, the decision is determined by nine specialist honours committees in the government responsible for reviewing and validating nominations. 45 per cent of the honours awarded in 2014 were in the field of Community, Voluntary and Local Service. For the first time in 2014 the number of honours awarded was evenly split between females and males.

OPPOSITE *Star of the Order of the Garter made for Queen Victoria in 1838*

PERCENTAGE OF 2014 AWARDS

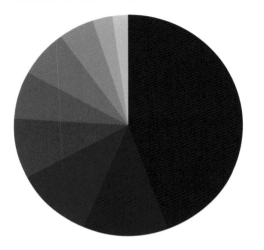

CATEGORY	PERCENTAGE OF 2014 AWARDS
COMMUNITY, VOLUNTARY AND LOCAL SERVICE	45%
ECONOMY	12%
EDUCATION	11%
STATE	9%
ARTS AND MEDIA	7%
HEALTH	7%
SPORT	5%
SCIENCE AND TECHNOLOGY	2%
PARLIAMENTARY	2%

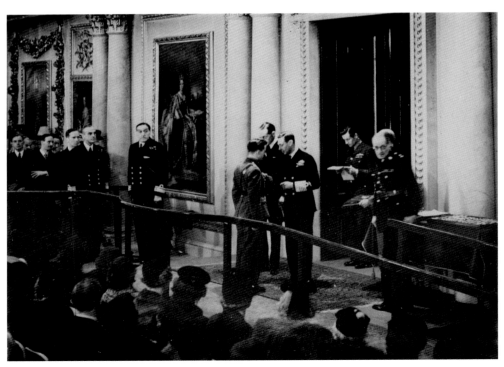

LEFT *The Investiture of Major Tasker Watkins VC in the Marble Hall at Buckingham Palace on 8 March 1945*

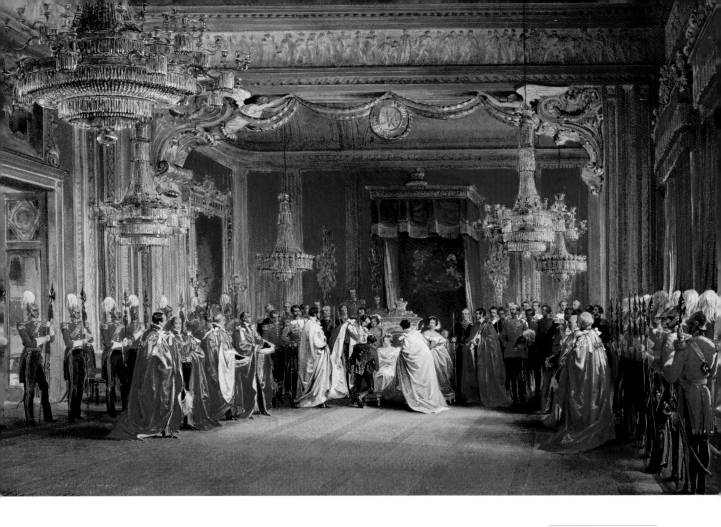

Before the Ballroom at Buckingham Palace opened in 1856, the Throne Room was used for Investitures and for the ceremonial reception of dignitaries. A watercolour by Louis Haghe shows an Investiture of the Order of the Bath taking place in 1855. Many of the recipients on this occasion were officers who had distinguished themselves in the Crimean War. In 1945 an Investiture was held in the Marble Hall at Buckingham Palace. A photograph of that day shows King George VI presenting the Victoria Cross to Major Tasker Watkins for his valour in single-handedly disarming an anti-tank gun post during the Second World War.

Today Investitures are held in the Ballroom, which is the largest room in the Palace and comfortably accommodates the recipients and

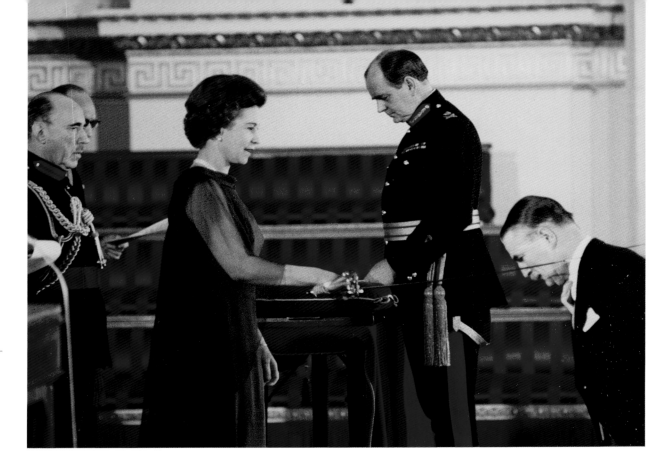

ABOVE *The Queen awarding a Knighthood in 1969*

their guests in comfort. The Central Chancery of the Orders of Knighthood, a branch of the Lord Chamberlain's Office, is responsible for the organisation of each Investiture. They coordinate the list of recipients, send out the invitations, prepare the Insignia and maintain the records relating to each Order. They are also responsible for briefing The Queen on each recipient's achievements.

On the morning of an Investiture, guests start arriving at Buckingham Palace at 10am. Recipients of awards are taken to the Green

I didn't realise how amazing it would be. You know, you think about investitures but until you are actually there you don't realise what it is like - I feel very proud and humbled. A unique opportunity.
MBE RECIPIENT, 2015

Drawing Room or the Picture Gallery, while their guests go to the Ballroom where The Countess of Wessex's String Orchestra plays in the Gallery. The music is a mix of classical and more contemporary pieces – in 2014 the repertoire included compositions by Handel and Mendelssohn as well as a medley of music by The Beatles and the film score of *Harry Potter*. Each recipient is allowed to invite three guests. Each guest is given a Souvenir Programme listing those being invested and

RIGHT *The Souvenir Programme given to each guest*

RIGHT *Guests in the Ballroom during an Investiture in December 2014*

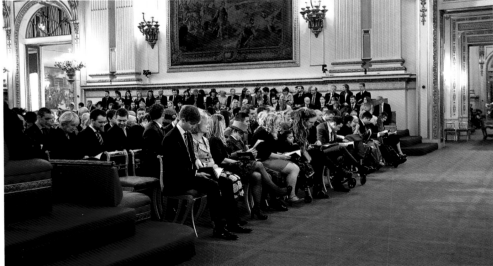

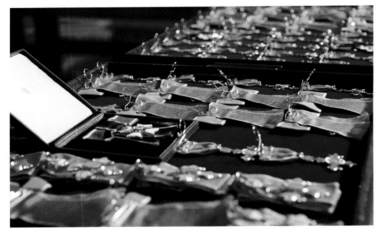

TOP *Recipients lining up in the Ballroom Annexe before being announced*

ABOVE *The Insignia is carefully arranged on trays in the correct sequence*

their awards. Recipients are briefed on what is to happen during the ceremony and a small hook is attached to their clothing if they are to receive a badge. At 11am The Queen enters the Ballroom attended by two Gurkha orderly officers, a tradition begun in 1876 by Queen Victoria. There are also five members of The Queen's Body Guard of the Yeomen of the Guard on duty on the dais. This Body Guard was originally founded by Henry VII in 1485 and is the oldest military corps existing in any country. Four Gentlemen Ushers look after the recipients and their guests.

Recipients line up in the Ballroom Annexe, grouped by the category of award they are to receive. After the National Anthem has been played, the name of each recipient and their achievement is announced by either the Lord Chamberlain or his representative and they proceed forward as their name is announced. The Queen is handed the Insignia on a velvet cushion and invests the recipient. She spends a few moments congratulating them and discussing their achievement. After a curtsey or bow, the recipient then passes into the Cross Gallery where their Insignia is removed, placed into its box, and returned to them. They then re-enter the Ballroom and take a seat to watch the rest of the ceremony. After the event, photographs are taken in the Quadrangle, and the Yeomen of the Guard are happy to pose with recipients and their guests. Approximately 90 people receive an award at an Investiture and each ceremony usually lasts just over an hour.

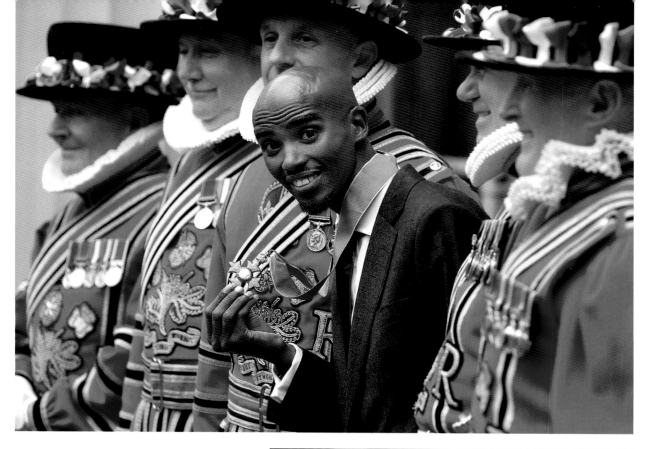

ABOVE *Olympic gold medalist Mo Farah with the Yeomen of the Guard after being invested with his CBE at Buckingham Palace in 2013*

RIGHT *Pamela Kenworthy being shown her Insignia after being invested as an OBE for services to legal aid*

ORDER	CLASS	LETTERS
THE MOST NOBLE ORDER OF THE GARTER	KNIGHT LADY	KG LG
THE MOST ANCIENT AND NOBLE ORDER OF THE THISTLE	KNIGHT LADY	KT LT
THE MOST HONOURABLE ORDER OF THE BATH	KNIGHT/DAME GRAND CROSS KNIGHT/DAME COMMANDER COMPANION	GCB KCB/DCB CB
THE ORDER OF MERIT	MEMBER	OM
THE MOST DISTINGUISHED ORDER OF SAINT MICHAEL AND SAINT GEORGE	KNIGHT/DAME GRAND CROSS KNIGHT/DAME COMMANDER COMPANION	GCMG KCMG/DCMG CMG
THE ROYAL VICTORIAN ORDER	KNIGHT/DAME GRAND CROSS KNIGHT/DAME COMMANDER COMMANDER LIEUTENANT MEMBER	GCVO KCVO/DCVO CVO LVO MVO
THE MOST EXCELLENT ORDER OF THE BRITISH EMPIRE	KNIGHT/DAME GRAND CROSS KNIGHT/DAME COMMANDER COMMANDER OFFICER MEMBER	GBE KBE/DBE CBE OBE MBE
THE ORDER OF THE COMPANIONS OF HONOUR	COMPANION	CH
THE IMPERIAL SERVICE ORDER	ISO	ISO
THE DISTINGUISHED SERVICE ORDER	COMPANION	DSO

There are six Orders of Chivalry and four Orders of Merit currently in regular use, and within many of these there are a number of different classes. The Insignia awarded reflects the class to which the recipient is appointed. A Knighthood – or Damehood for women – is the highest class for several of the Orders, and a separate honour class also exists which is known as a Knight Bachelor. During the knighting ceremony the recipient kneels on a velvet Investiture Stool and The Queen then lays a sword blade on the knight's right and then his left shoulder, an action known as 'dubbing'. The sword used by The Queen belonged to King George VI when, as Duke of York, he was Colonel of the Scots Guards.

ABOVE *Sword belonging to King George VI, which is now used by The Queen at Investitures*

OPPOSITE *The giltwood and crimson silk velvet Investiture Stool used during ceremonies for dubbing Knights*

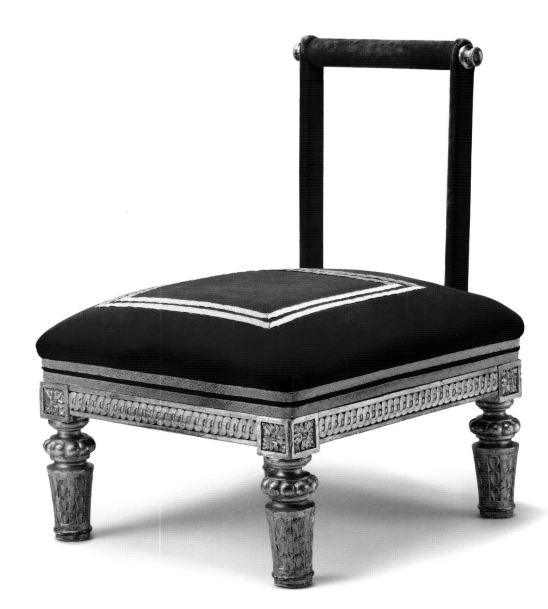

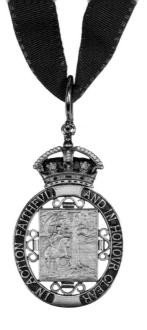

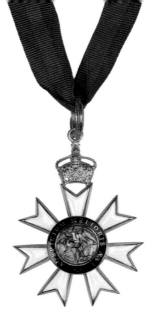

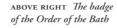

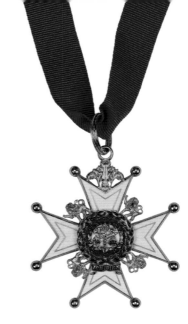

ABOVE LEFT *The badge of the Order of the Companions of Honour*

ABOVE CENTRE *The badge of the Order of St Michael and St George*

ABOVE RIGHT *The badge of the Order of the Bath*

RIGHT *Actress Kate Winslet with her Insignia of the Commander of the Order of the British Empire for services to drama*

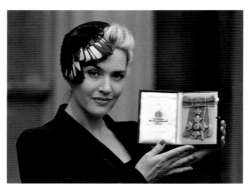

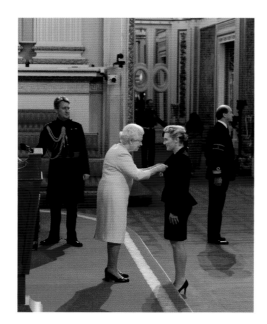

LEFT *Kate Winslet being invested as a CBE in 2012*

Appointments to the Order of the British Empire are the most numerous, and are made in one of five different classes GBE, KBE/DBE, CBE, OBE and MBE. Appointments to the Royal Victorian Order are made for personal service to Her Majesty and the Royal Family; recipients are often long-serving members of the Royal Household.

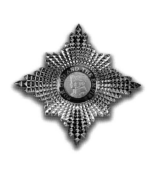

ABOVE *The badge of a Knight Bachelor*

RIGHT *Badges of the Order of the British Empire. For women the badges are attached to a bow, as here, while for men they are on a straight ribbon. Shown here are the Insignia for the Dame Grand Cross (top), Officer (left), and Member (right)*

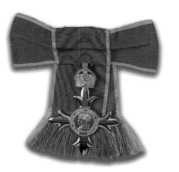

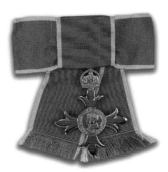

It's absolutely fantastic. You know, normally you stand outside the gates and you look in, wondering what it would be like. And here I am, I'm here and it's a fabulous experience, it really is.
MBE RECIPIENT, 2015

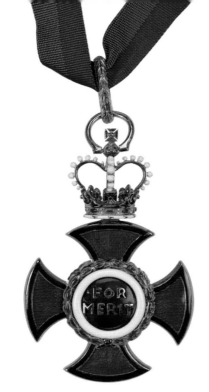

THE ORDER OF MERIT

The Order of Merit was founded by King Edward VII in 1902 to honour those who had 'rendered exceptionally meritorious service in Our Crown Services or towards the advancement of Arts, Learning, Literature, and Science'. It is the sole gift of the sovereign and there are a maximum of 24 members at any point in time. The badge consists of an eight-pointed cross of red and blue enamel, with 'For Merit' in gold lettering in the centre. Past British holders of the Order include Florence Nightingale, Sir Winston Churchill, the composer Sir Edward Elgar, the artists William Holman Hunt and Augustus John, the authors Graham Greene and Sir Tom Stoppard and the aircraft designer Sir Geoffrey de Havilland. The Order of Merit has also been awarded to a number of foreign recipients including Mother Teresa of Calcutta and Nelson Mandela.

ABOVE *The badge of the Order of Merit*

BELOW LEFT *Sir Edward Elgar by William Strang, 1911*

BELOW RIGHT *A chalk portrait of The Honourable John Howard by Ralph Heimans, 2013*

In 1906 King Edward VII authorised the commissioning of portrait drawings of members of the Order of Merit. A number of the earliest portraits were by William Strang and show an appreciation of the important collection of drawings in the Royal Collection by Hans Holbein the Younger. Like Holbein, Strang used red and black chalks on a prepared ground, and often captured a likeness with only a few lines. While the practice of commissioning portraits stopped with the outbreak of the First World War, it was revived by The Queen in 1987. More recent additions to the series include portraits of Sir Timothy Berners-Lee (inventor of the World Wide Web), John Howard, (Prime Minister of Australia from 1996-2007), Dame Cicely Saunders (St Christopher's Hospice founder) and a self portrait by David Hockney, which was created on an iPad. The drawings are kept in the Royal Library at Windsor Castle.

ABOVE *A self-portrait iPad drawing by David Hockney, 2013*

BELOW LEFT *Dame Cicely Saunders by George Bruce, 1992*

BELOW RIGHT *Sir Tom Stoppard by Daphne Todd, 2001*

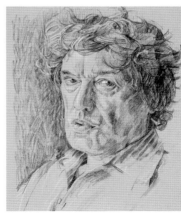

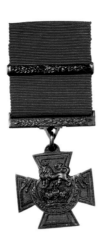
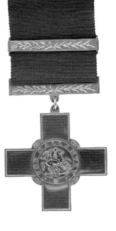
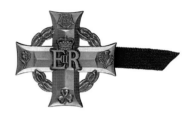

ABOVE LEFT *A Victoria Cross which dates from c.1856*

ABOVE MIDDLE *A George Cross which belonged to King George VI and dates from c.1940*

ABOVE RIGHT *The Elizabeth Cross*

AWARDS FOR GALLANTRY: THE VICTORIA CROSS AND THE GEORGE CROSS

While members of the Armed Forces are eligible for the military divisions of civilian honours, there are a number of military Decorations, which are given primarily to military personnel for gallantry and distinguished service. These include the Victoria Cross and the George Cross.

The Victoria Cross is the highest award for gallantry that a British or Commonwealth serviceman can achieve, and it was instituted by Queen Victoria in 1856 to recognise conspicuous bravery by people of any rank throughout the Armed Forces – it was unique in being open to all ranks. Queen Victoria herself suggested the medal should display the inscription 'For Valour' rather than the initial suggestion 'for the Brave', so as not to undermine the bravery of all service personnel. A watercolour by George Housman Thomas (overleaf) shows the distribution of the first Victoria Crosses, which was held in Hyde Park in 1857. Only 15 Victoria Crosses have been awarded since the Second World War,

the most recent to Lance Corporal Joshua Leakey in 2015.

The George Cross was instituted by King George VI in 1940 and ranks after the Victoria Cross as the highest award for gallantry. It may be awarded to civilians or military personnel, and is usually awarded for acts of extreme bravery. Other awards for gallantry include the Distinguished Service Order, the Conspicuous Gallantry Cross, the Military Cross, The Queen's Gallantry Medal, and the Royal Red Cross.

THE ELIZABETH CROSS

The Elizabeth Cross was created in 2009 and is awarded to the the Next of Kin of those Armed Forces personnel killed on operations or as a result of an act of terrorism. Its presentation signifies a national recognition for the family for their loss. The arms of the Elizabeth Cross bear floral symbols representing England (a rose), Scotland (a thistle), Ireland (a shamrock) and Wales (a daffodil), the design personally selected by The Queen.

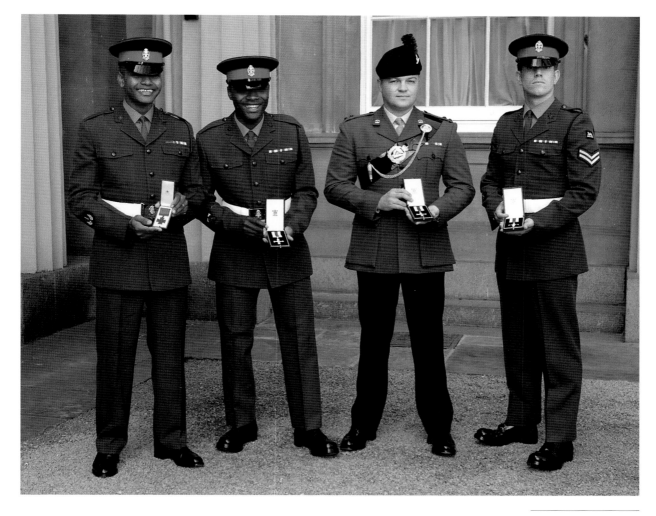

It's quite emotional really. I kept thinking of my dad, my mum and dad and how they would feel and my wife sitting in the audience, how she would feel, and suddenly, there's your Head of State, it's your Queen and to have that 30 seconds of her attention and conversation will just stay with you a lifetime. Just fantastic.

OBE RECIPIENT, 2015

ABOVE *Private Johnson Beharry with his Victoria Cross and Private Troy Samuels, Lieutenant Richard Deane and Corporal Brian Wood with their Military Crosses*

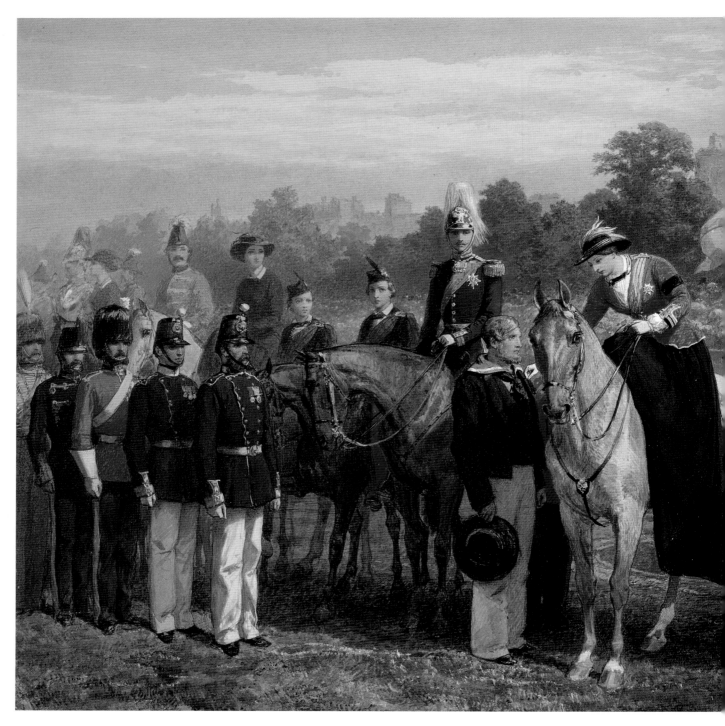

INVESTITURES

31

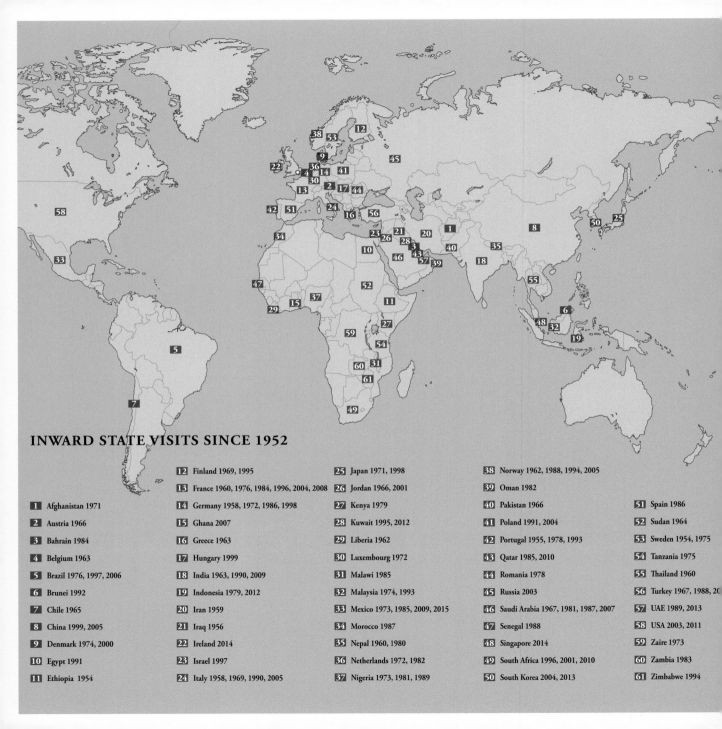

INWARD STATE VISITS SINCE 1952

1 Afghanistan 1971

2 Austria 1966

3 Bahrain 1984

4 Belgium 1963

5 Brazil 1976, 1997, 2006

6 Brunei 1992

7 Chile 1965

8 China 1999, 2005

9 Denmark 1974, 2000

10 Egypt 1991

11 Ethiopia 1954

12 Finland 1969, 1995

13 France 1960, 1976, 1984, 1996, 2004, 2008

14 Germany 1958, 1972, 1986, 1998

15 Ghana 2007

16 Greece 1963

17 Hungary 1999

18 India 1963, 1990, 2009

19 Indonesia 1979, 2012

20 Iran 1959

21 Iraq 1956

22 Ireland 2014

23 Israel 1997

24 Italy 1958, 1969, 1990, 2005

25 Japan 1971, 1998

26 Jordan 1966, 2001

27 Kenya 1979

28 Kuwait 1995, 2012

29 Liberia 1962

30 Luxembourg 1972

31 Malawi 1985

32 Malaysia 1974, 1993

33 Mexico 1973, 1985, 2009, 2015

34 Morocco 1987

35 Nepal 1960, 1980

36 Netherlands 1972, 1982

37 Nigeria 1973, 1981, 1989

38 Norway 1962, 1988, 1994, 2005

39 Oman 1982

40 Pakistan 1966

41 Poland 1991, 2004

42 Portugal 1955, 1978, 1993

43 Qatar 1985, 2010

44 Romania 1978

45 Russia 2003

46 Saudi Arabia 1967, 1981, 1987, 2007

47 Senegal 1988

48 Singapore 2014

49 South Africa 1996, 2001, 2010

50 South Korea 2004, 2013

51 Spain 1986

52 Sudan 1964

53 Sweden 1954, 1975

54 Tanzania 1975

55 Thailand 1960

56 Turkey 1967, 1988, 20

57 UAE 1989, 2013

58 USA 2003, 2011

59 Zaire 1973

60 Zambia 1983

61 Zimbabwe 1994

STATE VISITS

A STATE VISIT IS a formal visit to the UK by a Head of State from overseas, with the aim of strengthening diplomatic, professional and personal relations between the two countries. There are usually two incoming State Visits every year and each usually lasts three or four days. Planning for a State Visit takes place approximately 12 months before the visit and is a coordinated effort between the Foreign and Commonwealth Office of the government and the Royal Household. While The Queen issues the invitation and acts as the host on behalf of the UK, the choice of the country to be invited, and the programme, is made by the government. The Visit typically includes an intense series of engagements including meetings with ministers and leaders of commerce and industry. The schedule is carefully laid out in a bound programme. Special visits of particular interest to the guest are also arranged. For the State Visit of President Charles de Gaulle of France in 1960, the Royal Opera House staged a gala performance that included a production of *Coppélia*. As Head of State, The Queen is the official host for a State Visit, and the guest and their entourage stay at Buckingham Palace or at Windsor Castle, or occasionally at the Palace of Holyroodhouse. For State Visits at Buckingham Palace the visiting Head of State is usually given a suite of rooms on the ground floor of the Palace for the duration of their stay, with windows overlooking the garden. Known as the Belgian Suite, this set of rooms was first occupied by Leopold, King of the Belgians, uncle to both Queen Victoria and Prince Albert. Several other members of the guest's entourage are given bedrooms on the Principal Corridor on the

OPPOSITE *Inbound State Visits during The Queen's reign*

RIGHT ABOVE *Programme for the Singapore State Visit in 2014*

RIGHT BELOW *Silk programme for the gala performance held at the Royal Opera House in 1960 in honour of the French State Visit*

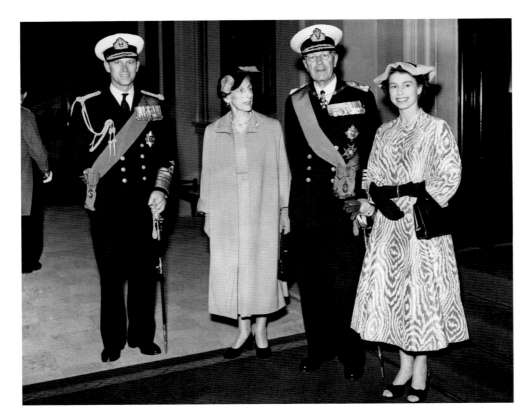

LEFT *The Queen and The Duke of Edinburgh welcoming King Gustaf VI Adolph and Queen Louise of Sweden to Buckingham Palace in 1954*

first floor overlooking The Mall. Each guest is given a bathrobe, slippers and set of toiletries, and a drinks tray is set out in their room along with a bowl of fruit.

THE STATE ARRIVAL

During her reign The Queen has welcomed 110 Heads of State on official State Visits. The first, in 1954, was King Gustaf VI Adolph with Queen Louise of Sweden, who arrived at Westminster Pier then travelled by State Landau to Buckingham Palace, escorted by the Household Cavalry. State visitors have also arrived by train to Victoria Station, to be met by The Queen and The Duke of

Edinburgh along with other senior members of the Royal Family and government. Today, the arrival has a set pattern, as in March 2015, when The Queen welcomed the President of the United Mexican States, Señor Enrique Peña Nieto, and Señora Angélica Rivera de Peña. The President was met with an official ceremonial welcome at the Royal Pavilion on Horse Guards Parade before travelling to Buckingham Palace in a state carriage procession along the Mall. For the most recent State Visits The Queen has travelled in the Diamond Jubilee State Coach with the guest of honour, while The Duke of Edinburgh escorts the guest's partner in the Australian

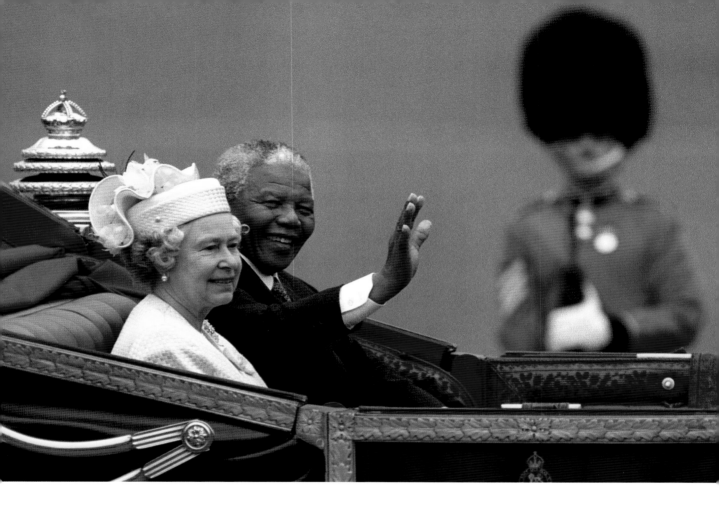

ABOVE *The Queen with Nelson Mandela, President of South Africa, on the first day of his State Visit in 1996*

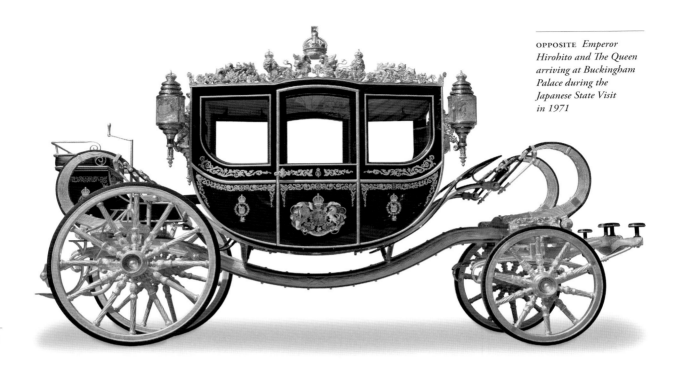

OPPOSITE *Emperor Hirohito and The Queen arriving at Buckingham Palace during the Japanese State Visit in 1971*

ABOVE *The Diamond Jubilee State Coach, built in 2012, is used to transport The Queen and the guest of honour to Buckingham Palace during a State Visit*

RIGHT *The Australian State Coach was presented to The Queen in 1988 by the people of Australia*

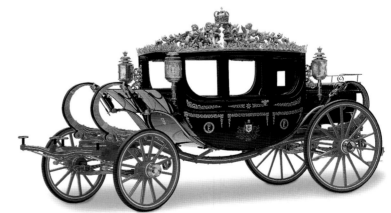

State Coach behind. Flags from the two countries line The Mall. Soldiers from the Blues and Royals regiment stand in position at the Grand Entrance while the Guard line up in the Quadrangle of the Palace and play the national anthems of the two countries as the coaches arrive. Photographs are usually taken of The Queen with her guests at the Grand Entrance before they sit down together for a private lunch.

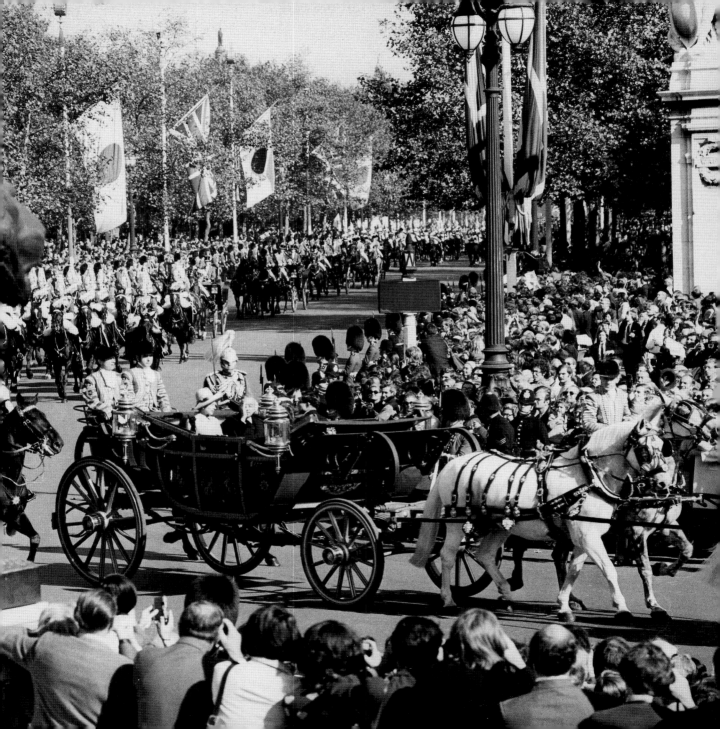

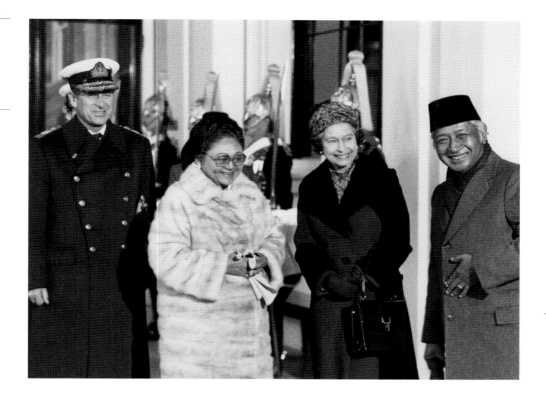

OPPOSITE ABOVE
The Guard lining up in the Quadrangle of Buckingham Palace during a State Visit arrival

OPPOSITE BELOW
The Diamond Jubilee State Coach arriving at the Grand Entrance of Buckingham Palace

ABOVE *President and Madame Soeharto of Indonesia with The Queen and The Duke of Edinburgh at the Grand Entrance of Buckingham Palace in 1979*

At the official welcome for the President of Singapore during the State Visit in 2014, The Queen wore a knee-length coat of navy blue wool designed by Karl Ludwig Couture over a navy blue silk dress decorated with pink and white flowers. It was accessorised with a matching hat trimmed with a pink flower, black shoes, bag and gloves. One of Queen Victoria's diamond bow brooches was pinned to the coat and The Queen wore her three-strand necklace of pearls.

BELOW *The Queen with Mrs Mary Tan during the ceremonial welcome for the State Visit in 2014*

ABOVE *Navy blue hat decorated with pink silk flowers designed by Angela Kelly Couture*

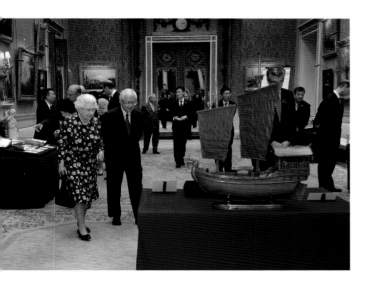

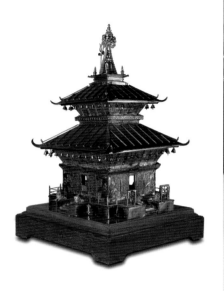

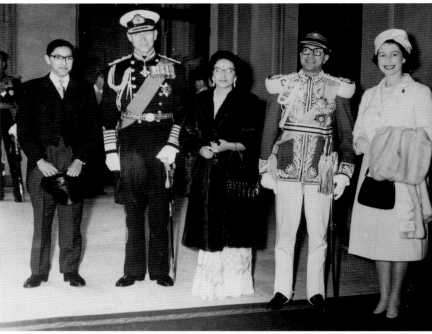

GIFTS

During a State Visit it is customary for gifts to be exchanged on the first day as a symbol of goodwill between the two countries. While the nature of these gifts varies, those presented by foreign visitors often represent traditional skills or crafts particular to their own country, or are of specific cultural significance. In 1960, for example, The Queen was presented with a model of the Pashupatinath Temple by King Mahendra Bir Bikram Shah of Nepal. This is one of the most sacred sites in Nepal and holds a particular significance to the country's majority Hindu population. It survived the devastating earthquakes in 2015. A bible presented by King Hussein of Jordan in 1966 is bound in leather and mother of pearl, carved with a nativity scene. It comes with a matching casket. During the State Visit in June 1976 The Queen was presented with a Sèvres dinner service by President Valéry Giscard d'Estaing of France. Made of hard-paste porcelain decorated with an abstract gilded cross-hatched design it pays homage to the long tradition of high quality ceramic manufacture in France, while also representing 1970s taste and aesthetics. In 2014 President Tan of Singapore also presented The Queen with a series of porcelain plates, hand-decorated with designs depicting locations she had visited during her three State Visits to Singapore in 1972, 1989

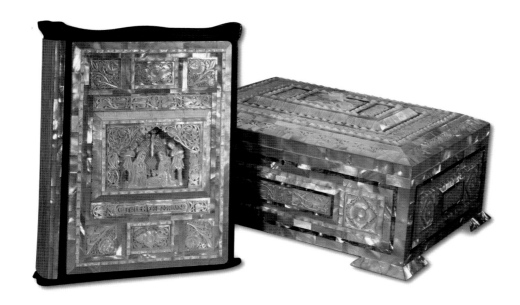

LEFT *Bible and casket decorated with mother-of-pearl, presented by King Hussein on the occasion of the State Visit of Jordan in 1966*

BELOW *Porcelain dinner service made by Sèvres and presented to The Queen by President Valéry Giscard d'Estaing of France in 1976*

STATE VISITS

43

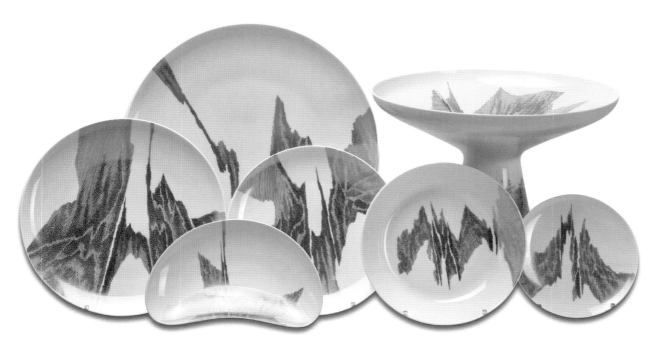

ABOVE *A set of porcelain plates presented by the President of Singapore in 2014*

and 2006. In return The Queen gave the President two books in a leather box, as well as a pair of photographs in silver frames. Among the gifts presented by the President of the United Mexican States during the State Visit in March 2015 was a 'Tree of Life', a traditional Mexican brightly-coloured clay sculpture. It is personalised with the figure of The Queen in yellow coat and hat, as well as various British landmarks.

After gifts have been exchanged The Queen escorts her visitor around a special display of objects which have been chosen for their interest. This display is usually set up in the Picture Gallery. The items are selected from the Royal Collection and Royal Archives and often include books, drawings and works of art. Many have been presented as gifts to members of the Royal Family on foreign tours or during earlier State Visits to Britain. The items shown to President Tan during his State Visit in 2014 included a wooden model of a Singaporean junk boat with red cotton sails, which had been presented to a ten year old Prince Charles

ABOVE *A ceramic 'Tree of Life' given by the President of the United Mexican States in 2015*

OPPOSITE *A wooden model of a junk boat displayed in the Picture Gallery during the State Visit for the President of Singapore in 2014*

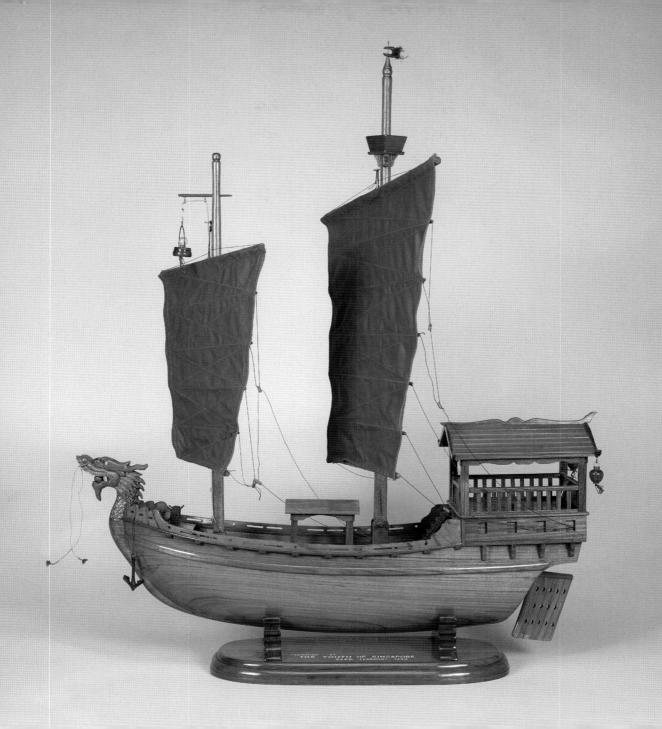

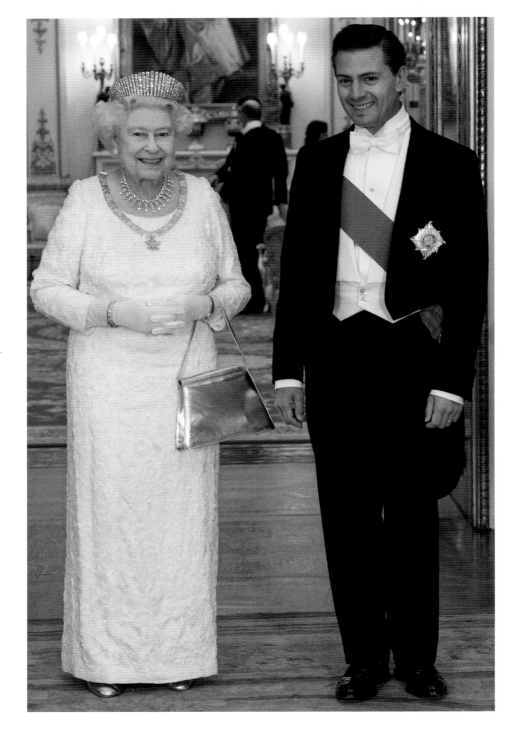

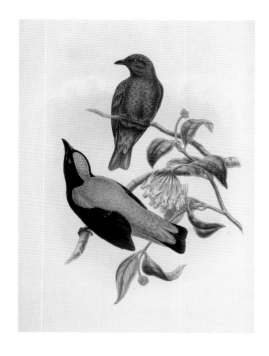

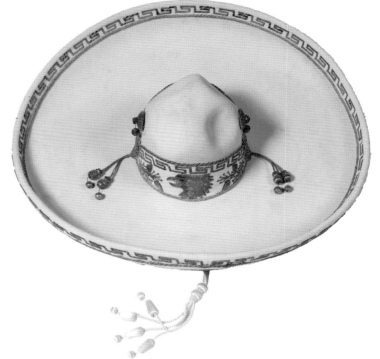

ABOVE *The Malayan Fairy Bluebird from roman 'The Birds of Asia' by John Gould, which was acquired by Queen Victoria*

RIGHT *A felt sombrero presented to The Queen by President Luis Echeverría of Mexico during his State Visit in 1973*

in 1959 by the Youth of Singapore. Also on display was a book illustrating *The Birds of Asia* dating from the 1880s, which included a variety of species indigenous to Singapore. The display for the President of the of the United Mexican States included a large white felt sombrero hat which had been presented to The Queen by President Luis Echeverría of Mexico during his State Visit to Britain in 1973. It is decorated with the head of an Aztec eagle.

BELOW *A drawing by Bryan de Grineau showing the State Banquet in the Ballroom for the French State Visit in 1950*

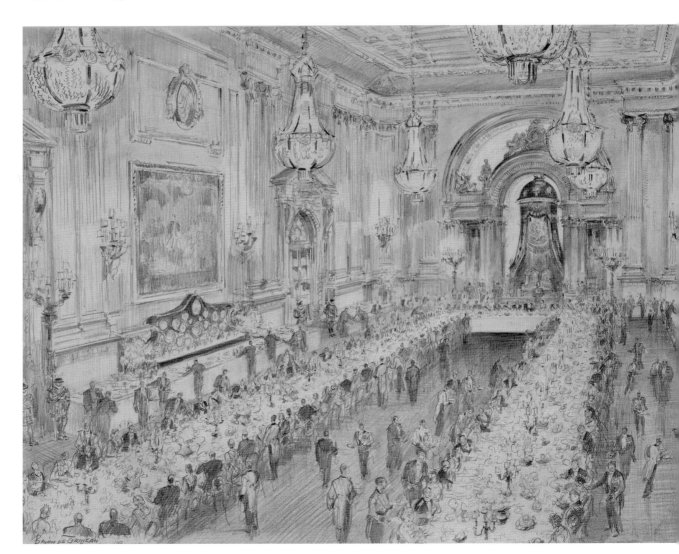

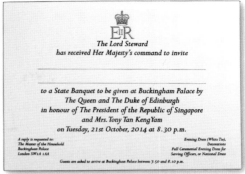

LEFT *Menu book showing the first menu for the first State Banquet held in the Ballroom in 1914*

ABOVE *The invitation to the State Banquet in 2014 in honour of the President of Singapore*

THE STATE BANQUET

A State Banquet for approximately 170 people is held on the first night of a State Visit. Since 1914 State Banquets in London have traditionally been held in the Ballroom at Buckingham Palace. Preparations for the banquet begin several weeks in advance, as the porcelain, glass and silver-gilt are cleaned, the damask tablecloths, napkins and doilies are pressed and the wine selected. Formal gilt-edged invitations are sent out approximately two months in advance and guests include members of the Royal Family, the visiting Head of State and their suite, members of the Cabinet and members of the main political parties, the Archbishop of Canterbury, the Speaker of the House of Commons, the Governor of the Bank of England, as well as guests whose background or work connects them to the visiting nation.

THE FOOD

The Royal Chef is responsible for managing the brigade of 20 chefs employed to cater for members of the Royal Family, their guests and the staff of the Royal Household. For a State Banquet additional support is often brought in from local catering colleges to cater for the guests, who must all be fed simultaneously, in addition to all the Household staff who support the event during the evening. The Royal Chef is responsible for devising the menu for a State Banquet, which traditionally consists of four courses. The first course will normally be a hot fish course, followed by a main course of meat or game. This is then followed by pudding, before finishing the meal at the table with the service of fresh fruit. It is also customary to serve a salad to accompany the main course, which is generally served on a separate crescent-shaped plate.

The Royal Kitchen places a strong emphasis on showcasing native products wherever possible – much of which is sourced from the Royal Estates at Sandringham, Balmoral and Windsor Home Park, or from other local suppliers. Guests at the State Banquet for the President of Singapore in 2014 were served *Paupiette de Sole Royale* (sole fillets with salmon mousse served on a bed of leeks with a white wine sauce) followed by poached breast of pheasant with truffles, crushed root vegetables and gratinated chard. A number of different options are always made available at each course to cater for any alternative diets.

The Royal Pastry Chef manages the sweet elements of the menus. Pudding for the State Visit in October 2014 consisted of *Bombe Glacée Sultane*, which is a chocolate ice cream

LE MENU

Paupiette de Sole Royale
———
Suprême de Faisan Farci Demi-Deuil
Concassée de Carottes et Suédois
Bette à Carde Gratinée
Fondant de Patate Douce
Salade
———
Bombe Glacée Sultane
———
Fruits de Dessert

LES VINS
Nyetimber Classic Cuvée 2007
Puligny-Montrachet 1er Cru "Les Folatières" 2006
 (Louis Jadot)
Château Pichon-Longueville Comtesse de Lalande 1990,
 Pauillac
Royal Tokaji Szt. Tamás, First Growth,
 6 Puttonyos Aszú 2007
Taylor Vintage Port 1977

MARDI LE 21 OCTOBRE 2014 BUCKINGHAM PALACE

LEFT *The menu for the Singapore State Banquet*

BELOW *Staff in the kitchen preparing the fish course for the Singapore State Banquet*

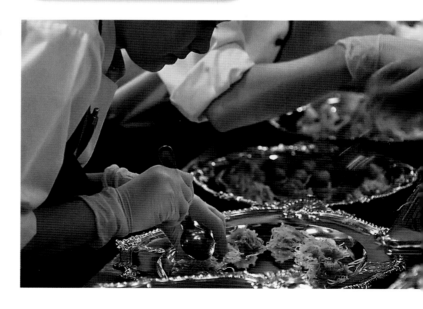

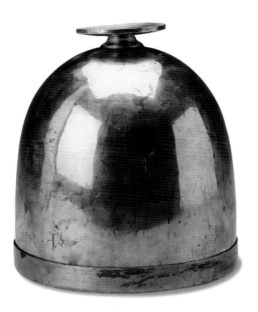

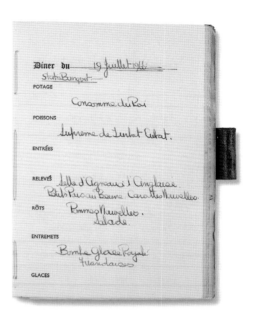

ABOVE *One of the traditional copper bombe moulds from the kitchen at Buckingham Palace*

ABOVE *Menu book showing the menu submitted for approval by The Queen for the State Banquet in 1966*

created using traditional copper moulds. The moulds are filled using an adapted chocolate cream which is frozen before being partially scooped out and a second flavour added to the centre. In this case the second flavour was praline. Once turned out the bombes are garnished with rows of specially cast chocolate buttons replicating those worn on the footman's uniform. A menu book from 1966 describes the menu served at the State Banquet held for King Hussein of Jordan on 19th July of that year, which also included

Bombe Glacée Royale. The fourth course is traditionally known as the 'dessert' service and consists of Fruits de Dessert - seasonal ripe fruit which is used to decorate the table during the banquet. Pineapples are prepared in advance, by removing the central fruit portion, which is then sliced into rings and replaced inside the intact shell. After the banquet silver-gilt platters of handmade *petit fours* are served with coffee to guests in the Music Room, State Dining Room and Blue Drawing Room. For the Singapore banquet

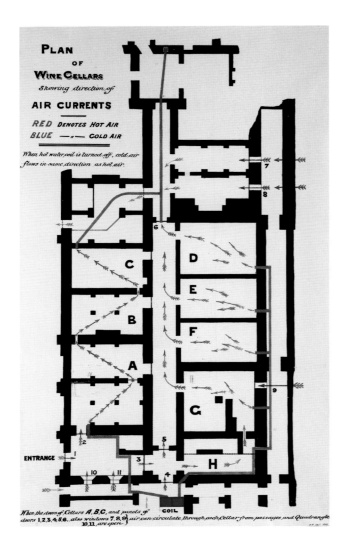

ABOVE *Plan of the wine cellars at Buckingham Palace*

these were decorated with delicate sugar flowers in the shape of white orchids, the national flower of Singapore. Around 350 *petit fours* are needed for a State Banquet, and they include both chocolates and *pâtes de fruit*. All are made by the Royal Pastry Chef and his or her team.

THE WINE

The cellars at Buckingham Palace date back to around 1700, making them the oldest part of the original building. They are kept cool by water from a bore-hole in the grounds of the Palace, which empties into the lake in the grounds. In total the cellars contain around 25,000 bottles of wine, which are carefully divided into those for private use and those for official entertaining. The Clerk of the Royal Cellars and the Yeoman of the Royal Cellars, in conjunction with the Head of Government Hospitality, choose the wine, which is selected to match the food once the menu has been approved. Usually each guest is served five different wines – champagne for the toast, white wine to accompany the fish course, red wine with the main, another type of champagne or dessert wine for the pudding and then port. For the State Banquet held in 2014 to honour the President of Singapore the wines included Puligny-Montrachet 1er Cru 'Les Folatières' 2006 and Royal Tokaji Szt. Tamás, First Growth, 6 Puttonyos Aszú 2007, from Hungary. On the afternoon of the banquet, each bottle is opened and tasted for quality. The port and claret are decanted using Edwardian silver funnels and muslin squares. Glass decanters, also dating back to the reign of Edward VII, are used and they are decorated with silver-gilt labels drawn

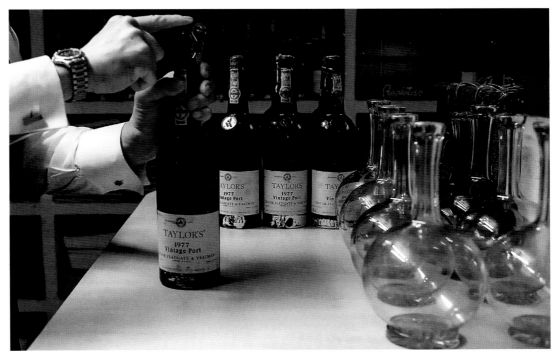

ABOVE LEFT *Silver-gilt port label*

ABOVE RIGHT *Claret jugs ready to be transported to the Ballroom in wicker baskets*

from the Grand Service, originally made for George IV, when Prince of Wales. It was first used at a banquet in 1811, although as King, George IV continued to add to the service and by his death it included more than 4,000 pieces. The decanters are carried in wicker baskets. Wine Butlers are responsible for serving all the drinks at a State Banquet, while the Yeoman of the Royal Cellars serves The Queen and her guest of honour. Wine and water are served from each guest's right-hand-side.

THE TABLE

The table is arranged in a horseshoe shape, with The Queen and her guest of honour seated at the top table and approximately 78 people positioned at the long side tables. The table is decorated with over 100 ivory-coloured candles in silver-gilt candelabra, along with displays of seasonal fruit and 23 flower arrangements in silver-gilt centrepieces, many purchased by George IV in the nineteenth century. Four of these matching centrepieces made by Paul Storr take the form of a convolvulus flower with four branches. Around the base of each are the figures of Pan playing a pipe, a maenad crashing the cymbals, as well as putti holding pan pipes and a tambourine. For the State Banquet in

ABOVE LEFT *Mercury and Bacchus candelabrum made by Paul Storr and purchased by George IV when Prince of Wales*

ABOVE RIGHT *One of the silver-gilt centrepieces from the Grand Service, which dates from 1812–21*

BELOW LEFT *Flowers being prepared in the Ballroom Annexe*

BELOW RIGHT *The final flower arrangement on the table for the Singapore State Banquet*

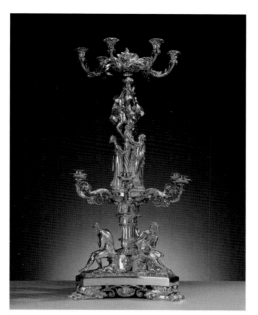

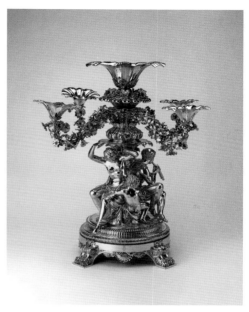

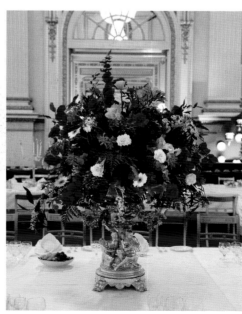

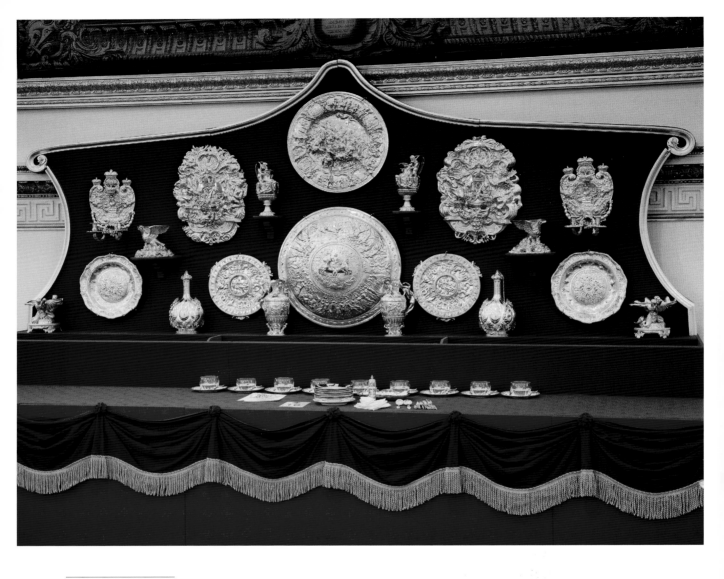

ABOVE *One of the two*
silver-gilt buffet displays
in the Ballroom during
a banquet, with a serving
station set up below

October 2014 the flowers in the centrepieces included Golden Dutch roses, hydrangea, red nerines, golden gerbera and leather-leaf ferns. The flowers are arranged in the Ballroom Annexe and then the centrepieces are placed into position once the rest of the table has been laid. Seasonal flowers are used, although care is always taken to ensure that they fit in with the red and gold colour scheme of the Ballroom. Along each side of the Ballroom are two 'buffet' displays, a tradition dating back for many centuries, when ornamental displays of the most precious silver, silver-gilt

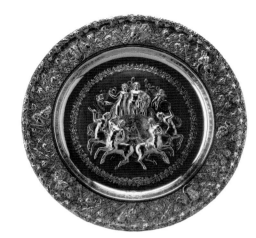

LEFT *Silver-gilt sideboard dish with a relief of the Triumph of Bacchus and Ariadne, hallmarked 1814/15 and made by Paul Storr*

BELOW *The sideboard dish being cleaned by a Footman in the Silver and Gilt Pantry*

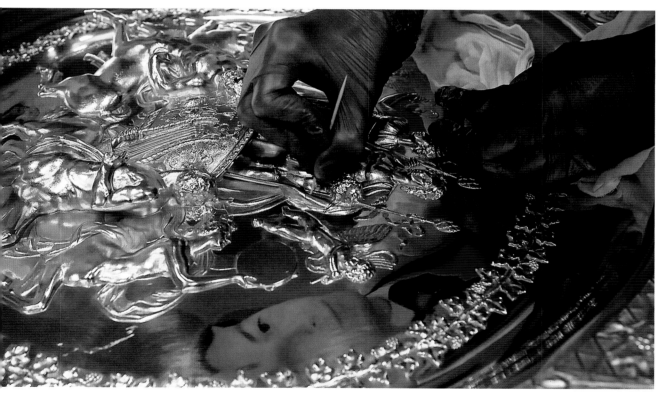

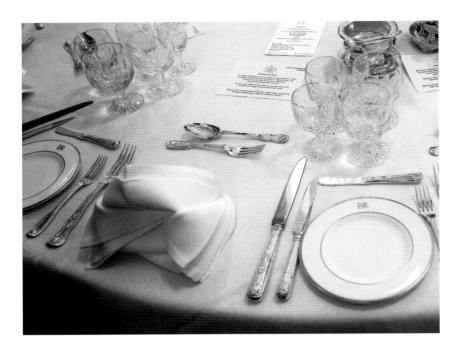

and gold vessels served both as a sign of respect to the rank of the guest, and as a symbol of the host country's power and wealth. The silver-gilt is the responsibility of the Yeoman of the Silver Pantry, whose team clean and polish each piece in advance of the banquet.

Each place setting is laid with a napkin folded into a Dutch-bonnet style, a side plate, two knives, two forks, a dessert spoon and fork, and a butter knife. Each person is also given six glasses, a champagne toasting glass, a glass for water, two for wine (one white and one red), a glass for the dessert course (either a port glass for Sauternes or a champagne glass) and a port glass. The glasses used were made for The Queen's Coronation in 1953 and each bears the EIIR cipher. A salt,

mustard pot and pepper castor are placed between every four guests. The main course is eaten off pre-warmed silver-gilt plates from The Grand Service. The third and fourth courses are usually served on porcelain, and several different services are used at State Banquets. During the State Banquet to honour the President of Singapore in 2014 the Minton service and the Tournai service were used. The Minton service was ordered by Queen Victoria in 1877 and has a turquoise ground (known as *bleu céleste*) with the VR cipher in the centre in gold. The Tournai service was made nearly 100 years earlier and was acquired by George IV, although it was originally commissioned from the Tournai factory in 1787 by Philippe,

RIGHT *Silver-gilt main course plate from the Grand Service*

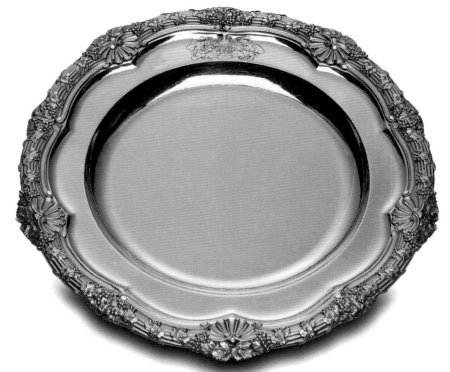

RIGHT *Minton bone china dessert plate made in 1877 for Queen Victoria*

FAR RIGHT *Plate from the Tournai porcelain service made in 1787*

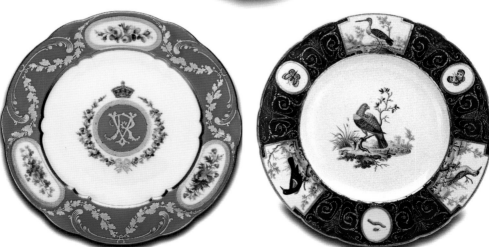

duc d'Orléans. These plates are decorated with a dark blue ground covered in gilding and images of birds and insects. In addition, porcelain services made by Sèvres and the Rockingham factory are mounted on stands around the rest of the Ballroom. The porcelain and glass are cared for by the Yeoman of the Glass Pantry and his or her team, who are also responsible for laying the linen tablecloths and folding the napkins. Once the table has been laid, the various elements are carefully lined up using a special ruler. The table is always personally viewed by The Queen on the afternoon of the event. This also provides an opportunity for her to thank the staff for their hard work during the preparations. Just before the guests arrive, the candles are lit and an individual paper shade placed over each one.

THE CLOTHES

Planning The Queen's wardrobe for a State Visit takes place several months in advance, and is coordinated by The Queen's Personal Advisor within the Dresser's department. A number of outfits are required, although the most high profile is that worn at the State Banquet. Guests to a State Banquet are expected to wear full evening dress, consisting of long dresses for

ABOVE
Preparing the cutlery for a State Banquet

BELOW
Footmen lining up the place settings and lighting the candles

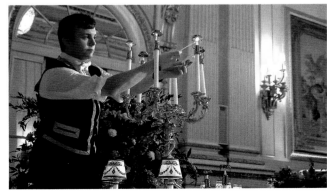

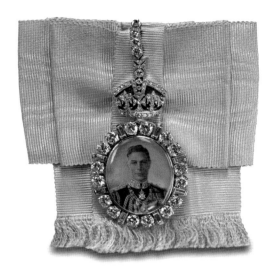

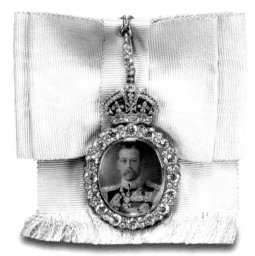

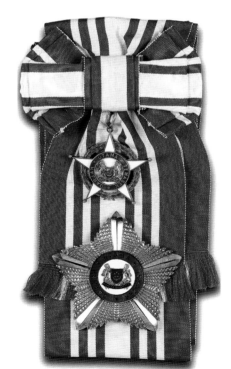

TOP LEFT *The Queen's Badge of the Royal Family Order of King George VI*

TOP RIGHT *The Queen's Badge of the Royal Family Order of King George V*

RIGHT *The Order of Temasek from Singapore, presented to The Queen in 1972*

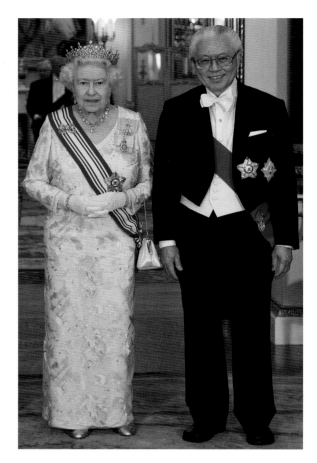

women and white tie for the gentlemen, or national dress. The Queen's attire at a State Banquet is usually pale, providing a neutral background to set off the colourful Insignia she wears, which are selected in honour of the visiting guest. For the State Banquet in 2014 in honour of the President of Singapore for example, The Queen wore the Badge and Riband as well as the Star of the Order of Temasek, which had been presented to her during her visit to Singapore in 1972. Pinned to the riband of the order she also wore her

LEFT *The dress worn by The Queen for the Chinese State Banquet in 1999, designed by Hardy Amies*

BELOW *The Queen and The Duke of Edinburgh with President Jiang Zemin and Madame Wang Yeping of the People's Republic of China before the State Banquet in 1999*

badges of the Royal Family Orders of King George V and King George VI. Her ankle-length dress was designed by Angela Kelly Couture and made from white silk covered with silver-grey abstract embroidery and decorated with crystals. The relatively simple design was deliberately chosen to emphasise the delicacy of the fabric, while enabling magnificent and sparkling jewels to be shown to best effect. While The Queen's dress for a State Banquet is often white, occasionally she wears a different shade. In 1999 for the State Banquet to welcome President Jiang Zemin of China she wore an apricot coloured dress of silk georgette and lace, embroidered with sequins and diamanté which was designed by Hardy Amies. On this occasion, she wears the Insignia of the Order of the Garter with its blue Riband and Badge.

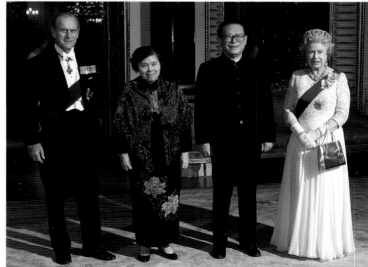

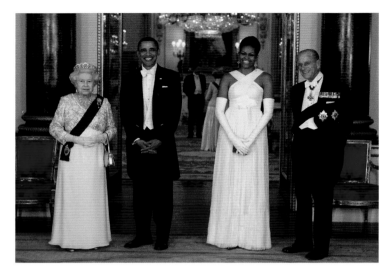

ABOVE *The Queen and the Duke of Edinburgh with President Barack Obama and Mrs Michelle Obama in the Music Room before the State Banquet in 2011*

LEFT *Dress designed by Stewart Parvin and worn by The Queen in 2011*

RIGHT *The dress worn by The Queen for the State Banquet in 1969 in honour of President Urho Kekkonen of Finland, designed by Norman Hartnell*

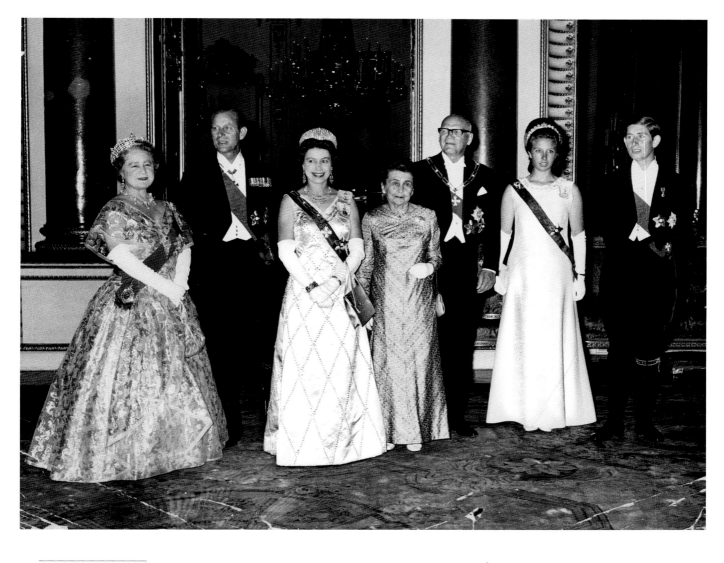

This was also the case during the 2011 State Visit of the President of the US, when The Queen wore the Order of the Garter over a long-sleeved dress of white silk crepe, with a bodice decorated with diamanté, sequins and short bugle beads. This dress was designed by Stewart Parvin.

For the 1969 State Banquet in honour of President Urho Kekkonen of Finland The Queen wore an ivory sleeveless dress of duchesse satin decorated with pearls, sequins, bugle beads, diamanté and drop crystals in a graduated geometric diamond pattern. This dress, designed by Norman Hartnell,

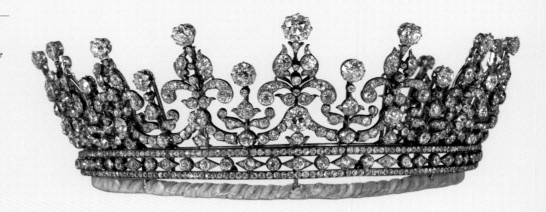

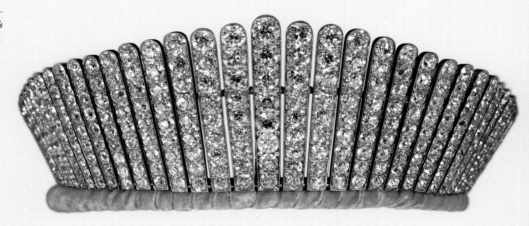

was worn again at the State Banquet in 1971 for Emperor Hirohito of Japan.

For the State Banquet The Queen always wears a tiara – at the Singapore State Banquet it was Queen Mary's *Girls of Great Britain and Ireland* tiara, which was made in 1893. Queen Mary gave it to her grand-daughter, Princess Elizabeth, as a wedding gift in 1947. It is one of the most familiar tiaras worn by The Queen since it appears on banknotes and

TOP LEFT *The Coronation earrings made in 1858 for Queen Victoria*

TOP RIGHT *Queen Mary's Dorset bow brooch made in 1893*

RIGHT *The Coronation necklace which was worn by Queen Alexandra, Queen Mary, Queen Elizabeth and The Queen at their Coronations*

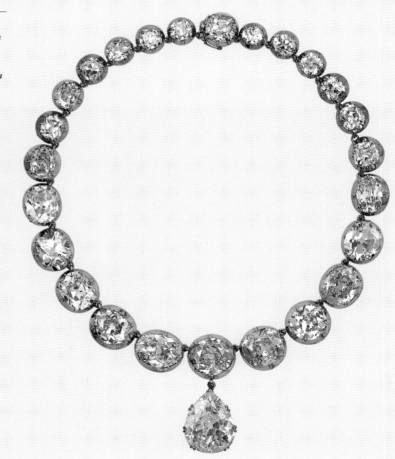

coins. Along with the tiara The Queen wore the Coronation necklace and earrings, and Queen Mary's Dorset bow brooch. This diamond brooch was a wedding gift to Princess Mary in 1893 from the County of Dorset, and was also given to Princess Elizabeth by her grandmother upon her wedding.

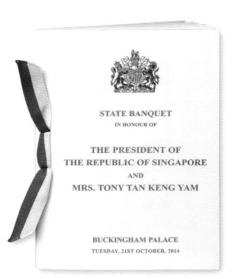

STATE BANQUET
IN HONOUR OF

THE PRESIDENT OF
THE REPUBLIC OF SINGAPORE
AND
MRS. TONY TAN KENG YAM

BUCKINGHAM PALACE
TUESDAY, 21ST OCTOBER, 2014

LEFT *Booklet given to guests at the Singapore State Banquet in 2014*

BELOW *Box containing the banquet booklets in alphabetical order*

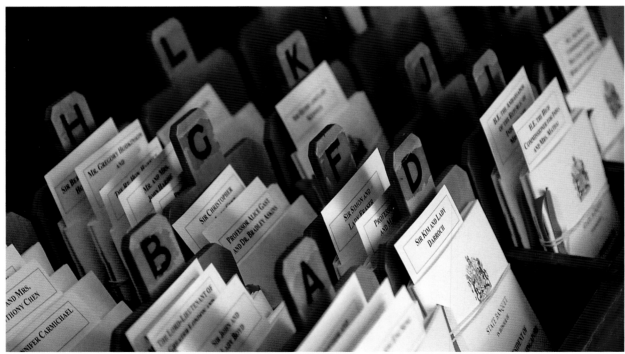

RIGHT *Red leather
seating planner for the
State Banquet at
Buckingham Palace*

For the State Banquet in honour of the President of the United Mexican States in 2015 The Queen chose to wear Queen Alexandra's Russian Kokoshnik Tiara. This tiara, which includes 488 diamonds set into 61 graduated platinum bars, was originally made for Alexandra, Princess of Wales as a silver wedding anniversary gift in 1888. Presented by 365 peeresses of the realm, it later passed down to Queen Mary, then to Queen Elizabeth in 1953. Around The Queen's neck was the Grand Collar of the Order of the Aztec Eagle, which was presented to her in 1973. The Kokoshnik tiara was also worn at the State Banquet in 1969 for President Urho Kekkonen of Finland along with the Hartnell dress.

THE EVENT

Guests begin arriving for a State Banquet at around 8pm. As each guest arrives they are given a booklet decorated with a ribbon in the national colours of the visiting country. These are stored alphabetically in a wooden banquet box. A table plan within the booklet is marked with the guest's position using a red dot, making it easy for them to find

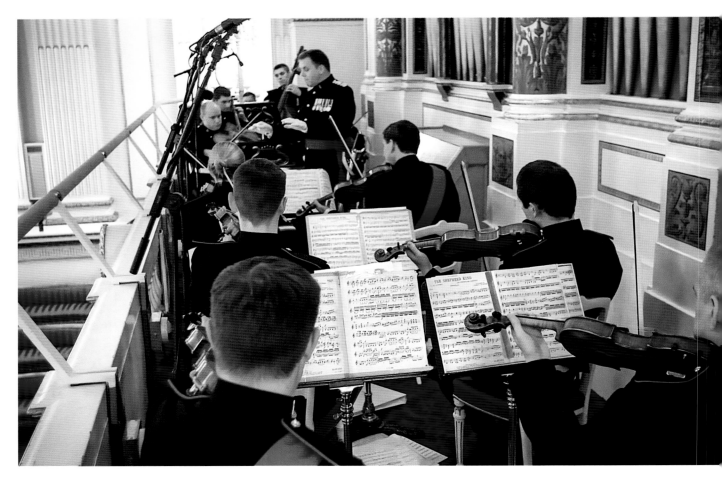

ABOVE *The Countess
of Wessex's string
orchestra playing in
the Minstrel's Gallery*

Music Programme

Classical	DIVERTIMENTO NO14 (1ST MOVT - ALLEGRO)	Mozart arr Conley
Nocturne	A MIDSUMMER NIGHT'S DREAM	Mendelssohn
Waltz	THE WESTMINSTER WALTZ	Farnon
Romantic	SALUT D'AMOUR	Elgar
Song	A FOGGY DAY	Gershwin
Fantasia	GREENSLEEVES	Vaughan Williams
Baroque	CONCERTO FOR TWO GUITARS (ALLEGRO IN G)	Vivaldi
Waltz	CAFÉ MOZART	Karas
Song	WHAT I DID FOR LOVE	Hamlisch
Folksong	SHENANDOAH	arr Krogstag
Suite	ENGLISH FOLK SONG	Vaughan Williams
Film Theme	SOMEWHERE IN TIME	Barry
Intermezzo	BELLS ACROSS THE MEADOWS	Ketelbey
Waltz	DAYS OF GLADNESS	Ancliffe
March	FROM RICCARDO	Handel
Medley	THE BEATLES FOREVER	arr Moore
Musical	ANTHEM FROM CHESS	Andersson/Ulvaeus
Paso Doble	AMPORITO ROCA	Texidor

Major Philip Stredwick
Director of Music
The Countess of Wessex's String Orchestra

Pipe Programme

March	MUIR OF ORD	
Strathspey	CAPTAIN COLIN CAMPBELL	
Reel	CAPTAIN LACHLAN MACPHAIL OF TIREE	
March	THE GORDONS MARCH	

Pipe Major Peter McGregor
4th Battalion Royal Regiment of Scotland (The Highlanders)

LEFT *Music programme for the State Banquet to welcome the President of Singapore*

ABOVE *The Royal Procession in the East Gallery*

their seat. The seating plan is devised by the office of the Master of the Household using a red leather seating planner. Careful attention is paid to whether guests have sat next to each other in the past, and if required an interpreter can be seated behind the guest to facilitate communication with their neighbour. The booklet also includes the guest list, the menu (which is written in French as the classic language of gastronomy) as well as the wine list and the music which will be played by the string orchestra and the pipers. The Director of Music is responsible for selecting the music – for the State Banquet in honour of the President of Singapore The Countess of Wessex's string orchestra played music by Mendelssohn, Vivaldi and Gershwin. As with all elements of the banquet, the music programme is personally approved by The Queen.

Guests are directed to the Picture Gallery for a pre-banquet reception. Official photographs of The Queen and The Duke of Edinburgh with the guests of honour are usually taken before the State Banquet in the Music Room. Guests are then presented to The Queen, the guests of honour and The Duke of Edinburgh, then pass into the Ballroom to find their seats. The Royal Procession, headed by the Lord Chamberlain and the Lord Steward, each carrying his white wand of office, pass down the East Gallery into the Ballroom and make their way to the top table as all the guests remain standing. The Queen welcomes her visitor, who is positioned to her right, and gives a short a speech. The visitor then responds similarly. After the speeches, food service commences. The Queen's Body Guard of the Yeomen of the Guard stand on

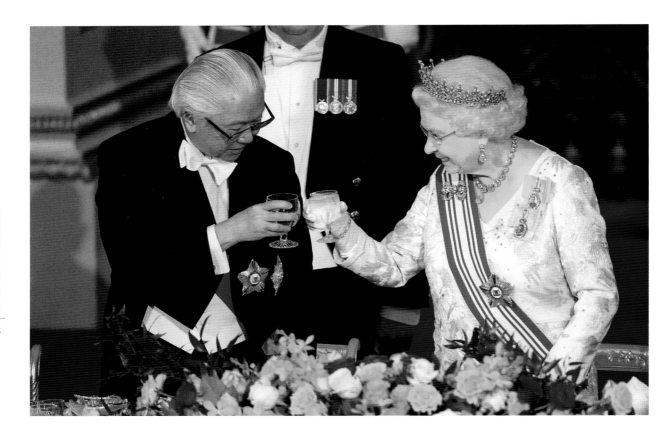

duty during the meal, guarding the entrances
and standing behind The Queen. The end of
the banquet at around 10:30pm is signalled
by the arrival of 12 pipers accompanied by
The Queen's Piper, a tradition dating back
to Queen Victoria. They enter from the East
Gallery and circle the Ballroom twice while
playing four or five pieces of music. After
dinner, coffee and *petits fours* are served to the
guests in the State Rooms and the banquet
table is cleared.

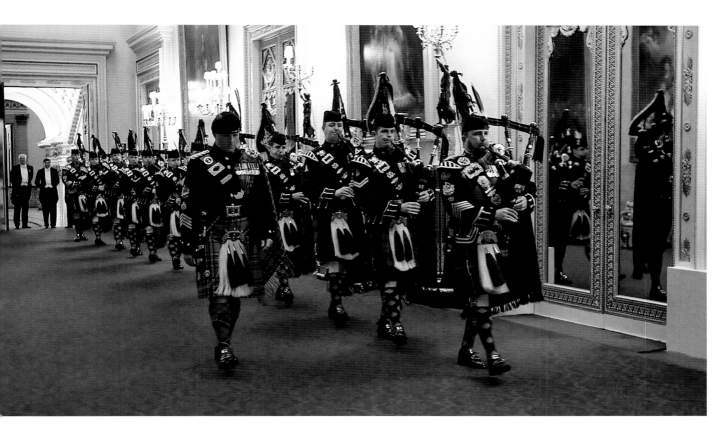

ABOVE *The Pipe Major leading Pipers from the 4th Battalion Royal Regiment of Scotland*

THE SERVICE

Staff serving at the banquet are coordinated by the Palace Steward. Around the edge of the Ballroom are 19 numbered serving stations. Each station is responsible for serving a group of approximately nine guests and is staffed by an Under-Butler, a Footman, a Page and a Wine Butler. Additional staff are often brought in from the other royal residences to work at the State Banquet. Under-Butlers and Footmen wear crimson and gold livery – a red tailcoat and black

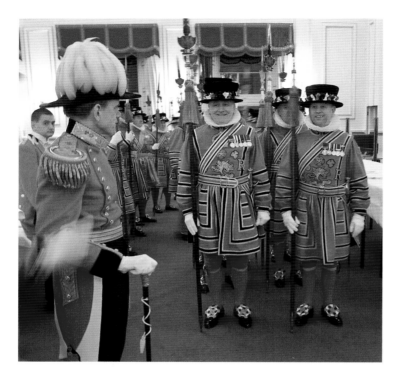

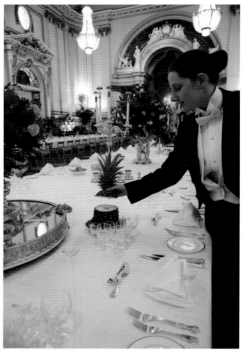

ABOVE *Yeomen lining up before a State Banquet*

ABOVE *The pineapples are placed on the table by a Page*

waistcoat both trimmed with gold braid, a stiff white shirt and white bow tie, black trousers and polished black shoes. The Page and Wine Butler wear a black coatee, black trousers and a white waistcoat. A traffic light system indicates when service is to begin, to ensure that it is coordinated across the different stations. Each Page places the food down for the first guest in their group at exactly the same moment. Food is brought up from the kitchen in portable ovens via the lift and taken into the Ballroom Annexe, then brought to the serving stations by the Under-Butlers. The meal is served to the guests 'butler style', so each diner serves the food

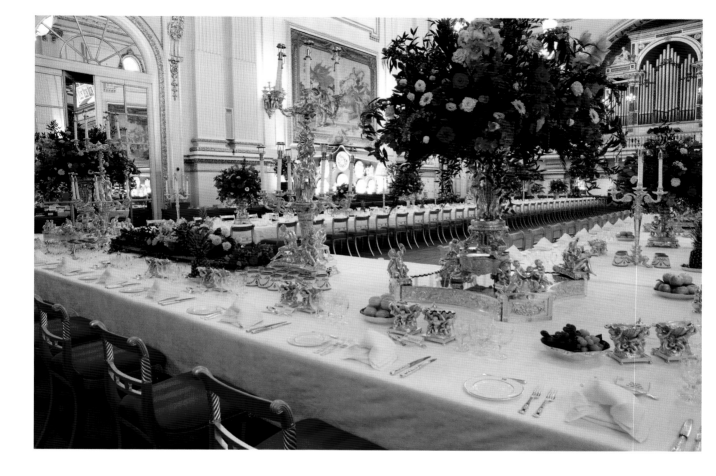

themselves from silver-gilt platters which are presented to them on their left-hand-side. The four courses are served sequentially, a style known as *service à la russe*, which was gradually introduced in the nineteenth century and replaced the *service à la française* used during royal banquets in earlier centuries, when numerous plates and tureens were laid simultaneously on the table from which the guests helped themselves from.

Plates are removed as each guest finishes their course. Finger bowls with doilies are provided with the fruit course. Plates are cleared to the serving stations then removed to the nearby Ball Supper Room to be carefully washed and stored away until they are next required.

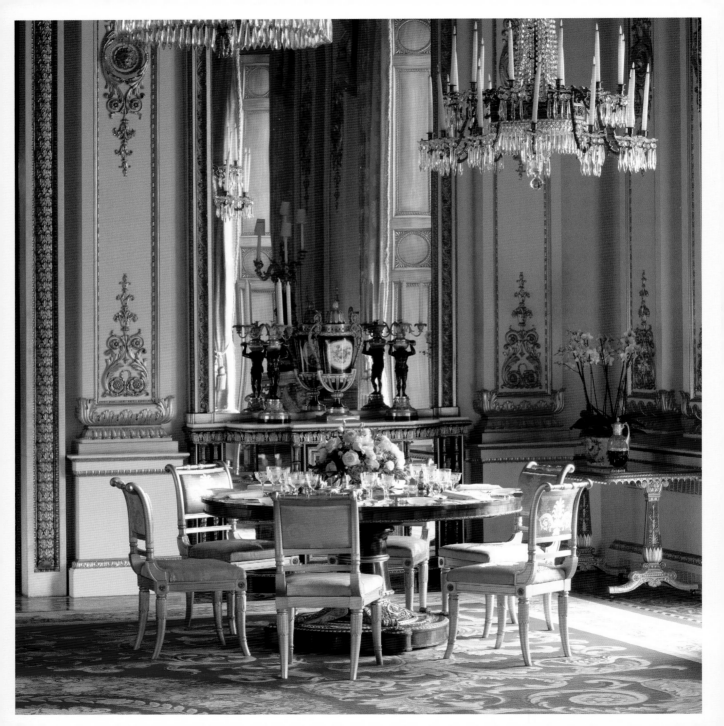

RECEPTIONS & LUNCHEONS

DURING 2014 OVER 340 receptions, luncheons and dinners were held at Buckingham Palace, at which nearly 11,500 people were entertained. These ranged in scale from an intimate lunch for a few guests to the annual Diplomatic Reception for 1,000 people. Some were hosted by The Queen, others by other members of the Royal Family. On 6th November 2014 The Duke of Cambridge and Prince Harry hosted the Recovery Pathway Reception for 350 people. This event was held to recognise military and civilian professionals who have helped members of the Armed Forces afflicted by physical or psychological injuries in the line of duty. Later that month The Earl of Wessex held a dinner for supporters of the Central

OPPOSITE *A table laid for a luncheon in the White Drawing Room*

BELOW *The Queen, The Duke of Cambridge and Prince Harry meeting guests in the White Drawing Room at the Recovery Pathway Reception in 2014*

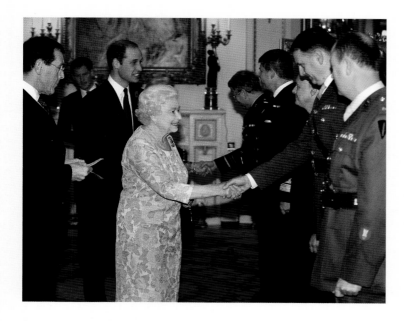

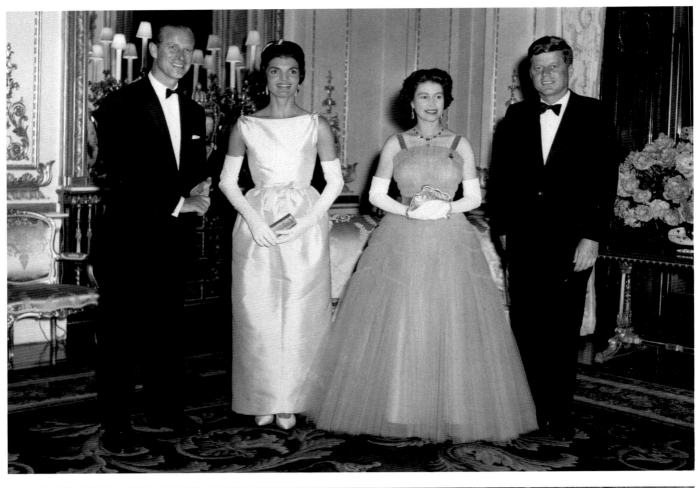

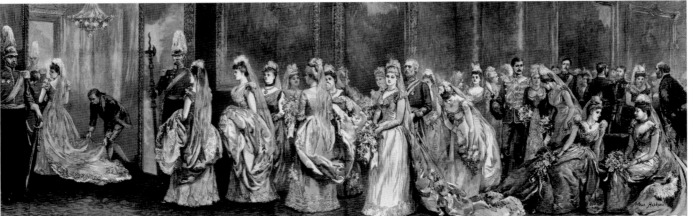

Caribbean Marine Institute, a marine conservation charity of which he is Patron. Smaller dinners are also held for foreign Head of State who are visiting in an unofficial capacity. President J.F.Kennedy and his wife Jacqueline were given a dinner party in their honour during their private visit in 1961.

The tradition of introducing young women, or 'debutantes', to the Royal Family at presentation parties can be traced back to the eighteenth century, when marriageable daughters were presented to Queen Charlotte by their mothers. Presentation parties were an important part of the nineteenth-century court calendar, marking the beginning of what was known as the London 'Season'. A drawing from 1891 shows the format

of such events. The women would line up, each wearing a white dress with a train of a specified length depending on her status, a veil, feathers in her hair and carrying flowers. Each would be presented to Queen Victoria in turn, and would curtsey then withdraw without turning her back. Once a woman had 'come out' in this way she was allowed to attend society events and was deemed eligible for marriage. A preparatory study for a lost painting by Sir John Lavery shows the Ballroom at Buckingham Palace during a court presentation party in 1931. Various figures in white evening dress are shown in the foreground, while King George V and Queen Mary are seated on thrones on the raised dais. They are surrounded by soldiers

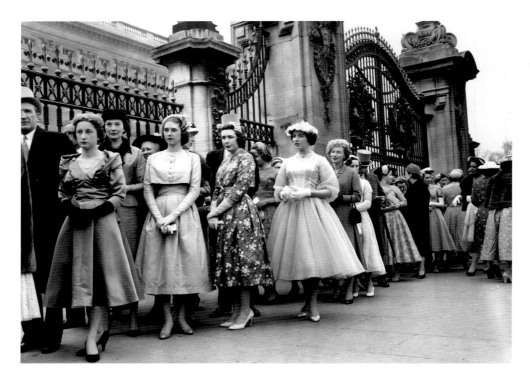

LEFT *Debutantes attending a presentation party at Buckingham Palace in 1957*

in red and men in black evening dress. The artist was given permission to observe the occasion on 20th May 1931. Presentation parties continued for the first six years of The Queen's reign, but the last debutante was presented in 1958 and the tradition was discontinued.

In the nineteenth century court events were restricted to the aristocracy. Today a much broader group of people are invited to events at Buckingham Palace. Often such events are used to recognise achievement in a particular field. On 16th October 2008 The Queen hosted a reception for over 500 people to celebrate the success of the 2008 Great Britain Olympic team in Beijing, who

won a total of 47 medals – 19 gold, 13 silver and 15 bronze. The reception was hosted on the evening of the parade through London which was attended by thousands of people, and Her Majesty met medallists including Chris Hoy and Rebecca Adlington in the Blue Drawing Room. On 17th February 2014 The Queen and The Duchess of Cambridge attended a reception to celebrate the dramatic arts. The 250 invited guests included actors, playwrights, teachers, producers and directors. The evening began with performances in the Ballroom from current RADA students and alumni, as well as a scene from *Pygmalion* and

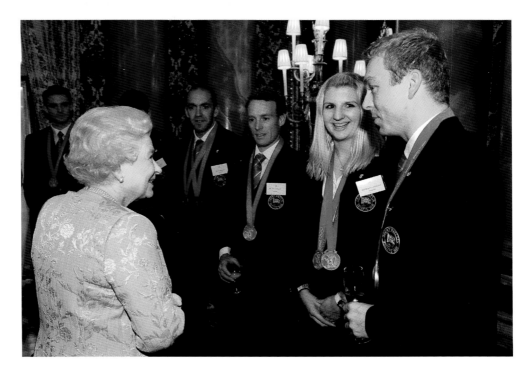

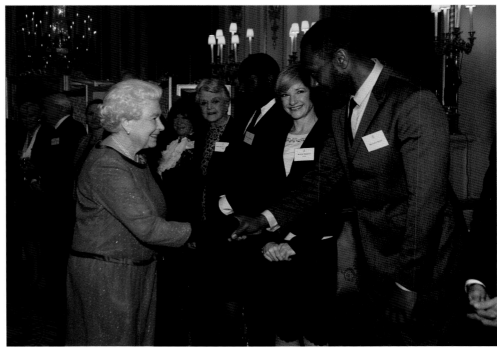

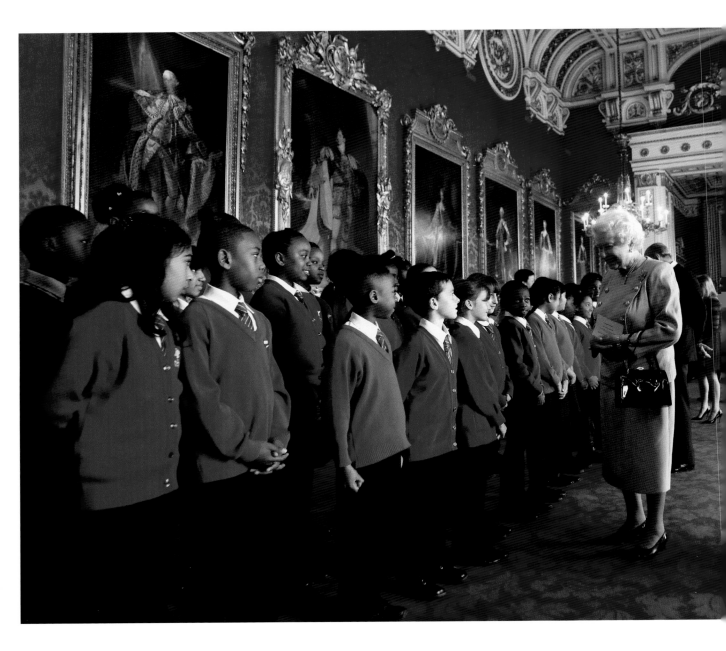

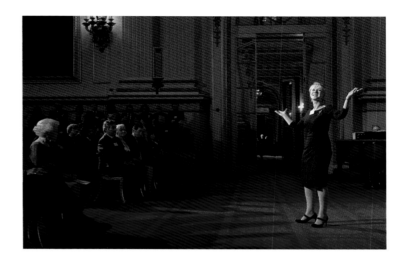

LEFT *The Queen meeting pupils from St Winefride's school in the State Dining Room in 2013*

ABOVE *Dame Helen Mirren performing a scene from* The Tempest *in the Ballroom*

monologues from *The Dresser* and *The Tempest* performed by Sir Tom Courtenay and Dame Helen Mirren.

Young people are also often invited to events at the Palace. In October 2013 a reception was held for Youth, Education and the Commonwealth. Guests included 21 pupils from St Winefride's school in Manor Park who sang at the event with the Commonwealth Orchestra and Choir. They were introduced to The Queen and The Duke of Edinburgh in the State Dining Room. Every year, over 100 young people are invited to a Young Achievers' Reception at Buckingham Palace for their work as volunteers for St John Ambulance or as carers for relatives. They are recognised for their commitment and bravery, and are introduced to The Princess Royal, who has the official title of Commandant-in-Chief (Youth) for St John Ambulance.

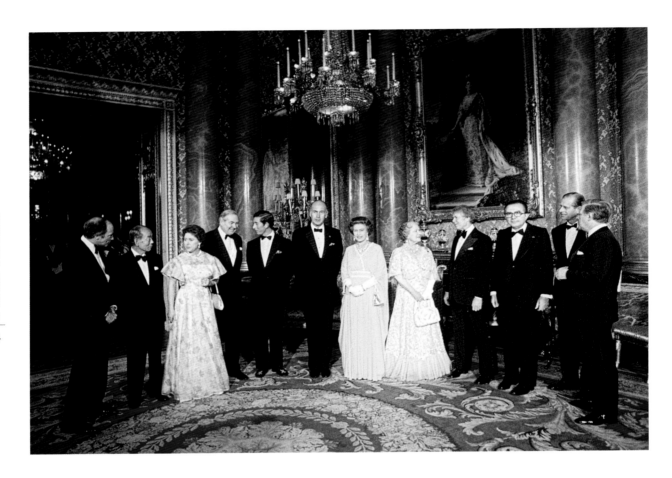

ABOVE *Members of the Royal Family with seven world leaders in the Blue Drawing Room in 1977*

Some events at the Palace continue to serve a political purpose in strengthening relations between different countries. On 7th May 1977 The Queen hosted a dinner at Buckingham Palace for seven world leaders who were in London for two days of summit talks at Downing Street. Attending were the UK Prime Minister, James Callaghan; US President, Jimmy Carter; President Giscard d'Estaing of France; the Prime Minister of

Italy, Giulio Andreotti; the Prime Minister of Canada, Pierre Trudeau; the Prime Minister of Japan, Takeo Fukuda and Helmut Schmidt, Chancellor of West Germany, along with various members of the Royal Family. Over 30 years later, on 1st April 2009, The Queen hosted a drinks reception in the Picture Gallery for delegates of the G20 London summit. Guests were presented to The Queen and The Duke of Edinburgh in the Music

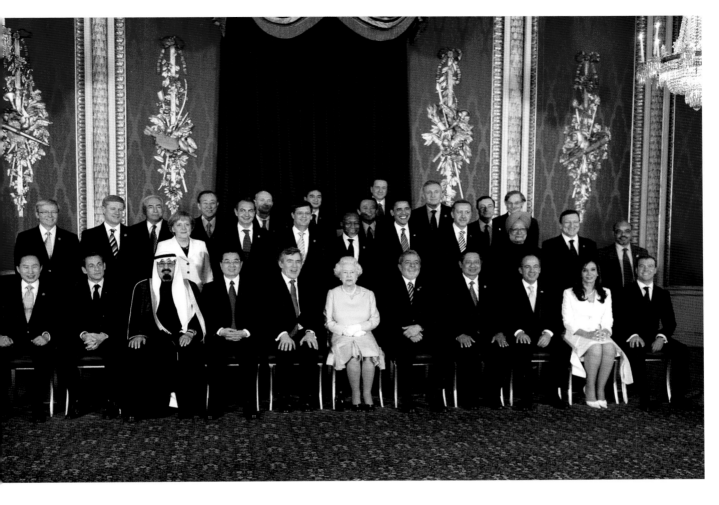

Room, while a formal photograph of the
G20 leaders was taken in the Throne Room.

In 1976 The Queen welcomed six Albertan
Indian chiefs and their wives to Buckingham
Palace who were in Britain to commemorate
the signing of two treaties with Queen Victoria
in 1866 and 1867 between the Crown and
Saskatchewan and Alberta tribes.

ABOVE *The Queen with
G20 leaders in the Throne
Room in 2009*

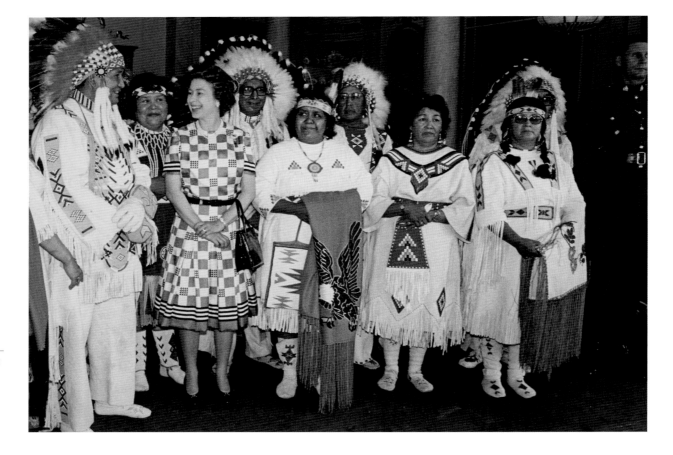

ABOVE *The Queen in the Bow Room with Albertan Indian chiefs and their wives in 1976*

The Diplomatic Reception, generally held in November each year, is the largest annual reception at Buckingham Palace, with a guest list numbering around 1,000. The invitation list is coordinated by the Marshal of the Diplomatic Corps and invitations are sent to all the ambassadors and high commissioners at the foreign missions in London, as well as past Prime Ministers, the Archbishops of Canterbury and York and other public figures. Diplomats enter by the Ambassador's Entrance instead of the Grand Entrance and come from over 130 different countries.

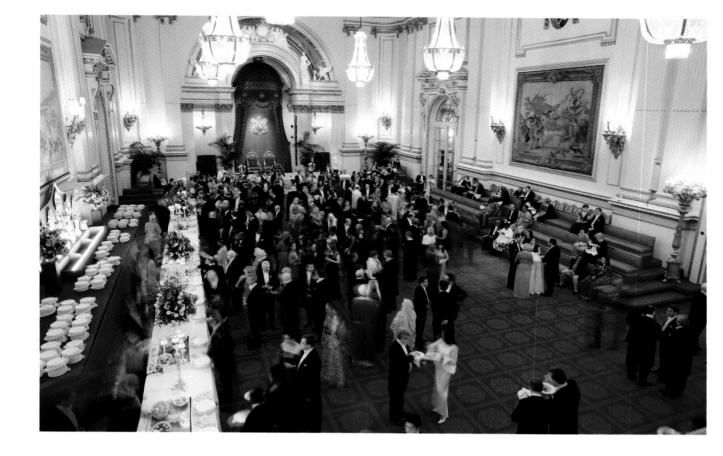

ABOVE *Guests dining in the Ballroom during the Diplomatic Reception in 2014*

The dress code is white tie or national dress making the event a particularly colourful occasion. Drinks are first served in the Green Drawing Room and the Picture Gallery then guests are served a buffet supper in the Ballroom in two sittings. Once the first group of guests has been served, Palace staff quickly clear the first service and return the Ballroom to its perfect appearance in time for the second. After the supper a band plays in the Ball Supper Room and many of the guests dance.

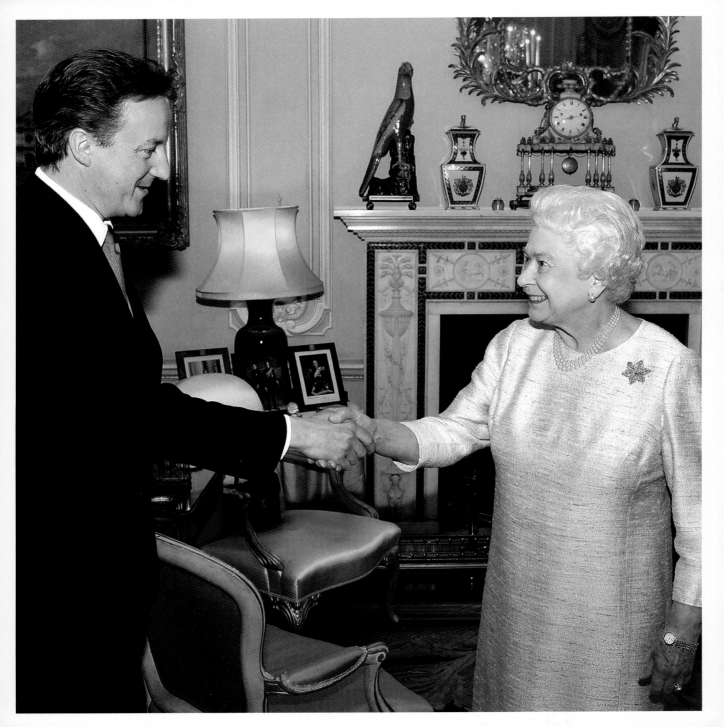

PRIVATE AUDIENCES

IN ADDITION TO HOSTING a large number of official events throughout the year at Buckingham Palace, The Queen also conducts private audiences, both formal and informal, each of which usually lasts about 20 minutes. The Queen gives a weekly audience to the Prime Minister. These meetings are strictly confidential, and if either party is not available to meet in person, they will speak on the telephone. There have been 12 Prime Ministers during The Queen's reign with whom she has held such audiences. Her Majesty will also have a private audience with the Chancellor of the Exchequor before a new budget is announced, as well as with visiting Heads of State who are not attending on an official State Visit. She also meets with Privy Council members, foreign and British Ambassadors and High Commissioners, bishops, senior officers of the Armed Services and the Civil Service. On 28th May 1982 she held an audience with Pope John Paul II, and in so doing was the first Monarch since the Reformation to welcome a pope to Britain.

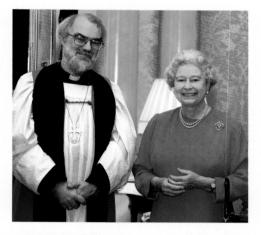

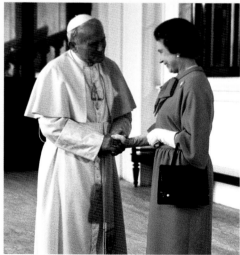

OPPOSITE *The Queen meeting Prime Minister David Cameron in The Queen's Audience Room in 2010*

RIGHT ABOVE *The Queen with the Archbishop of Canterbury Dr Rowan Williams in 2002*

RIGHT BELOW *The Queen with Pope John Paul II in 1982*

At Buckingham Palace audiences are either held in The Queen's Audience Room on the first floor or on the ground floor in the 1844 Room, which lies between the Belgian Suite and the Bow Room. The 1844 Room is named after the year in which it was decorated to receive Tsar Nicholas I of Russia by Queen Victoria. It is recognisable by its yellow pillars and gilt furniture with blue silk upholstery.

Sometimes, high-ranking Insignia are presented during a private audience instead of an Investiture, as in the case of Angelina Jolie in 2014 who was presented with the Insignia of an Honorary Dame Commander of the Most Distinguished Order of St Michael and St George for services to UK foreign policy and the campaign to end sexual violence in war zones. This award is generally used to recognise service to the Crown overseas.

Important audiences held in the 1844 Room include is the presentation of Credentials. Soon after arriving in London, newly appointed foreign ambassadors or Commonwealth High Commissioners are required to present their Letters of Credence or Letters of High Commission from their country's Head of State to The Queen. This formal ceremony has its origins in the nineteenth

ABOVE *A watercolour by James Roberts showing the newly decorated 1844 Room at Buckingham Palace*

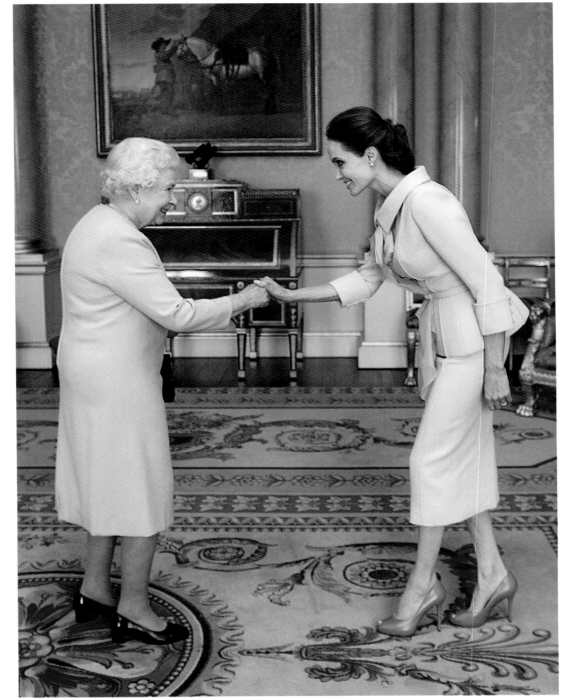

RIGHT *The Queen meeting
Angelina Jolie in the
1844 Room*

century, and visitors are escorted by the Marshal of the Diplomatic Corps in a State Landau from their embassy to Buckingham Palace. Visitors attending such audiences often wear the national dress of their country. They are accredited to the Court of St James's in London. After the private audience the Ambassador's suite is also presented to The Queen, and he or she signs The Queen's visitor book.

PRIVY COUNCIL MEETINGS

The Privy Council dates back to the eleventh century, and is the oldest legislative body in the United Kingdom. It originally functioned as the most powerful decision making body in the country, with members appointed by the Monarch to advise on matters of state. As jurisdiction has shifted over time to the democratically elected government its role has changed in emphasis. Today it is largely

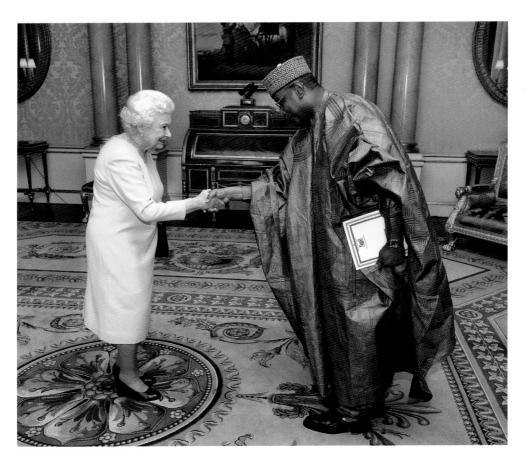

Mr Abderahamane Assane Mayaki, the Ambassador of the Republic of Niger, presenting his Credentials to The Queen in 2014

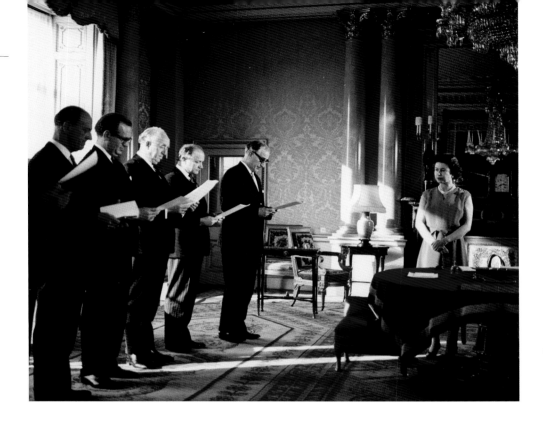

concerned with formal functions, many relating to the Monarchy, such as the granting of Royal Charters. The Privy Council also approves the design of new coinage, sets bank holidays, and appoints members to regulatory professional bodies. Privy Council meetings serve as a means for Orders to be approved by The Queen after having been discussed in advance by government ministers. While in Tudor times Privy Council meetings were 'privy' (private), the proceedings are now published and are publicly available for everyone to read.

Privy Council meetings are chaired by the Monarch and are held regularly throughout the year, usually around once a month, at the various different royal residences. Over 600 people from various walks of public life are Privy Councellors and different members are invited to each meeting depending on the agenda. Four council members are usually present, although sometimes more. Since Queen Victoria's reign meetings have always been held standing up. When they take place at Buckingham Palace they are held in the 1844 Room, next to the Bow Room. In advance of the meeting the circular table is set up with a red tablecloth and a candle to melt the red sealing wax for the Great Seal of the Realm, after which Proclamations become official.

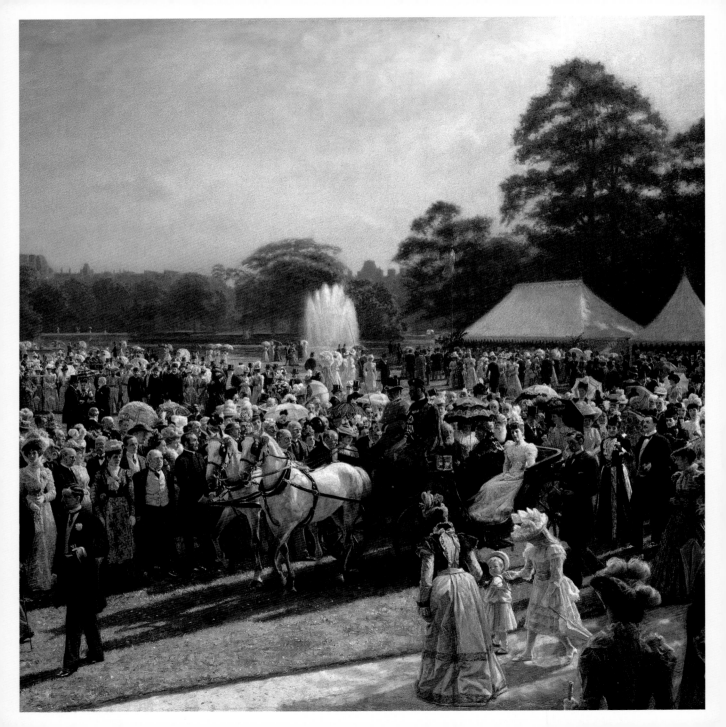

GARDEN PARTIES

SINCE 1952 AT LEAST three of the principal garden parties have been held every year at Buckingham Palace, each of which is now attended by approximately 8,000 people. Originally in July, they are currently held in May and June. Another garden party is held at the Palace of Holyroodhouse while the court is in residence in Scotland at the end of June or beginning of July. Garden parties have been held at Buckingham Palace since the 1860s when Queen Victoria introduced what were called 'breakfasts' – although they were in the afternoon. Frederick Sargent's painting (overleaf) shows a garden party to celebrate Queen Victoria's Golden Jubilee in the grounds of Buckingham Palace on 20th June 1887. The Queen is shown in the centre being introduced to two guests, with The Prince of Wales beside her. The west front of the Palace is in the background. Another painting (left), this time by the Danish artist Laurits Tuxen, depicts a garden party ten years later to commemorate the Queen's Diamond Jubilee. Queen Victoria and Alexandra, Princess of Wales are shown returning to the Palace in an open-topped carriage pulled by two grey horses. The Royal tea tent can be seen on the right. According to the artist's diary Tuxen was commissioned to paint a picture of the Jubilee garden party at which would be present the 'the cream of London society … as well as everybody from the entire British Empire who had connections with the court of St James's'. A photograph from the same event (overleaf) shows a view of the Palace across the lawn, the ladies wearing fashionable dresses with bustles and parasols, the men with black silk top hats and canes.

Over time, the range of different types of people invited to garden parties has evolved. In the early years of Her Majesty's reign they replaced formal presentation parties for debutantes, which were discontinued by The Queen in 1958. The invitation list has become ever more representative of the wide variety of people who live in the UK, with people invited from all walks of life upon the recommendation of a large

The Lord Chamberlain is
commanded by Her Majesty to invite

..

..

to a Garden Party
at Buckingham Palace
on Tuesday, 12th May, 2015 from 4 to 6 p.m.

This card does not admit

OPPOSITE *The Garden Party at Buckingham Palace on 28th June 1897 by Laurits Tuxen*

ABOVE *Garden party invitation for 2015*

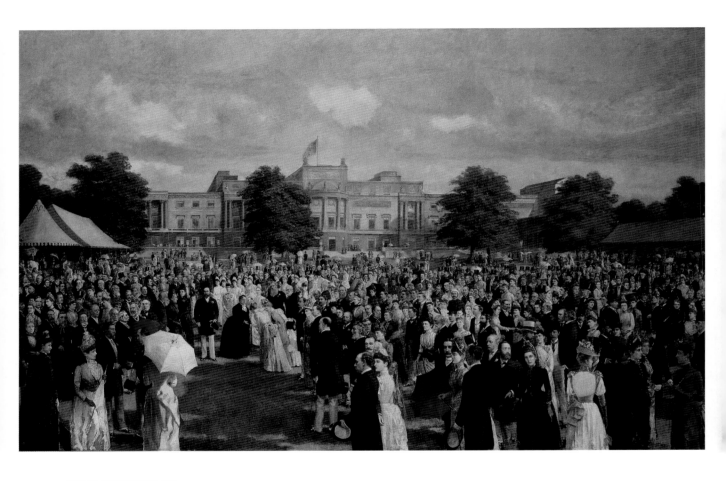

number of national and local organisations including the Civil Service, the Armed Forces, charities and societies. An invitation to a garden party provides a means for The Queen to recognise and acknowledge contributions to national life throughout the UK. Invitations are sent out by the Lord Chamberlain's department six weeks in advance although planning for a garden party begins six months before the event. Along with the invitation the envelope also includes an admittance card, security details, car parking badge and map. Each invitee is allowed to bring one guest – a partner, friend or relative. Men wear uniforms, morning dress or lounge suits, while women wear afternoon dress, usually with hats or fascinators. The Queen often wears a brightly coloured dress coat with a coordinating hat in order that she is clearly visible – for the garden party held on 30th

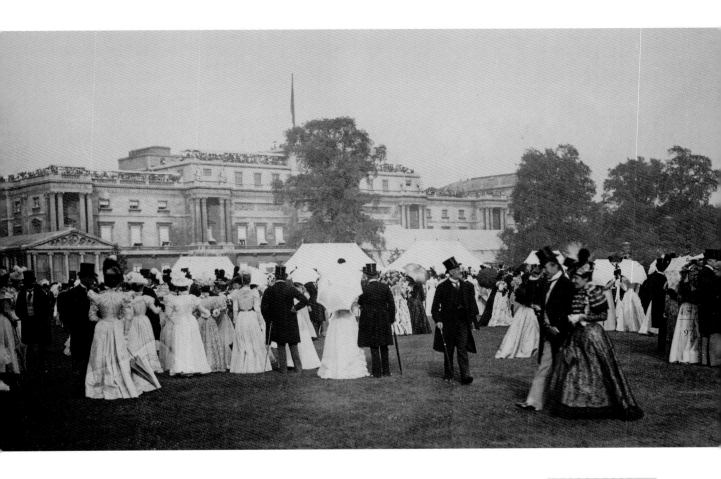

ABOVE *The garden party in 1897 to commemorate Queen Victoria's Diamond Jubilee*

This was the first time we had set foot in the gardens of Buckingham Palace. We were struck by their understated beauty. Likewise the good humour and friendliness of everyone, and the blend of tradition and informality is a memory that we will always treasure.
2015 GARDEN PARTY GUEST

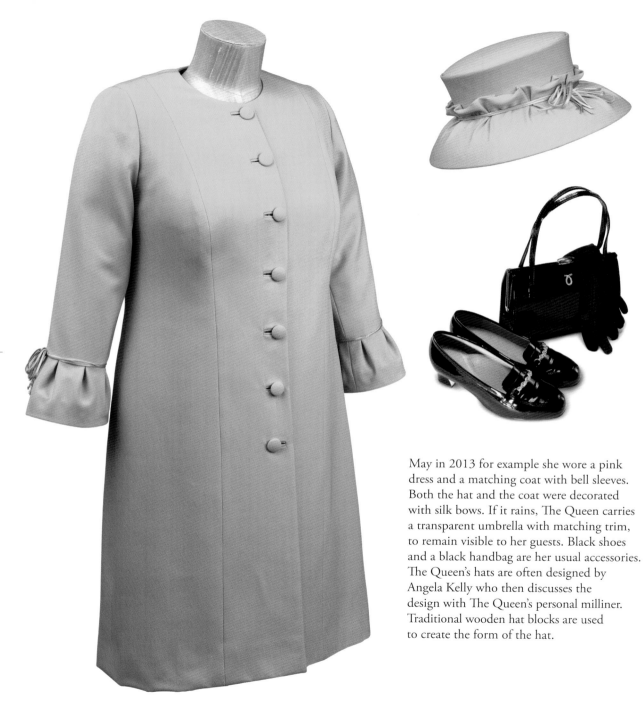

May in 2013 for example she wore a pink
dress and a matching coat with bell sleeves.
Both the hat and the coat were decorated
with silk bows. If it rains, The Queen carries
a transparent umbrella with matching trim,
to remain visible to her guests. Black shoes
and a black handbag are her usual accessories.
The Queen's hats are often designed by
Angela Kelly who then discusses the
design with The Queen's personal milliner.
Traditional wooden hat blocks are used
to create the form of the hat.

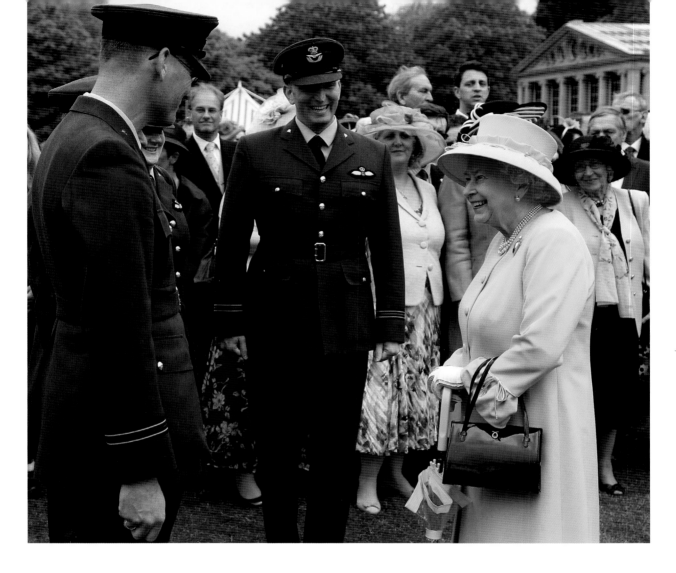

OPPOSITE *An outfit designed by Angela Kelly Couture and worn by The Queen at a garden party in 2013*

ABOVE *The Queen meeting members of the Royal Air Force Abingdon Volunteer Gliding Squadron at a garden party on 30 May 2013*

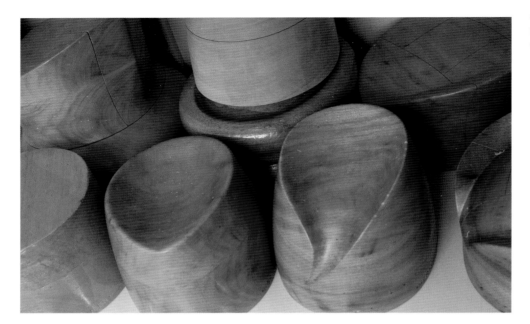

LEFT *Wooden hat blocks used to make The Queen's hats*

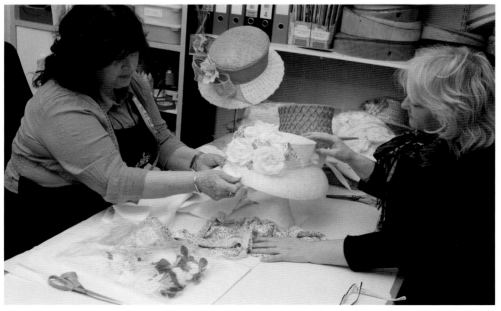

LEFT *Creating one of The Queen's hats*

Thank you so much for the wonderful afternoon tea at the Palace. One of the best days of my life. I enjoyed every minute. A memory of a lifetime!
2015 GARDEN PARTY GUEST

The Duke of Edinburgh wears a traditional morning suit – often a dark tailcoat over a grey waistcoat with dark grey trousers, a grey top hat and a brightly coloured flower in his buttonhole.

A highlight for many visitors to a garden party is the opportunity to wander freely amongst the gardens of Buckingham Palace which are not usually open to the public. Occupying just over 39 acres, the gardens serve as home to 30 resident species of bird and 320 types of wild flowers, in addition to those carefully planted and maintained by the Gardens Manager and his or her team along the herbaceous borders. The garden team work throughout the year, although in the run-up

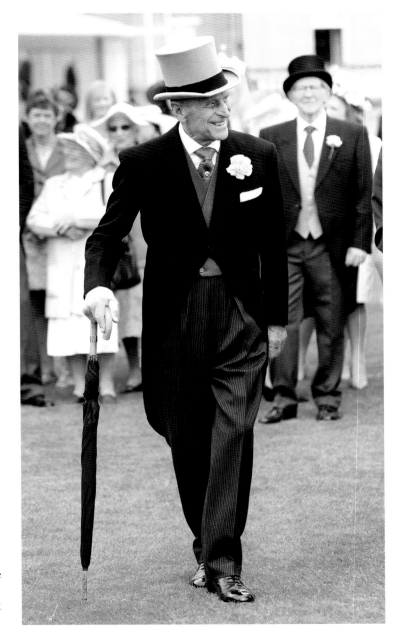

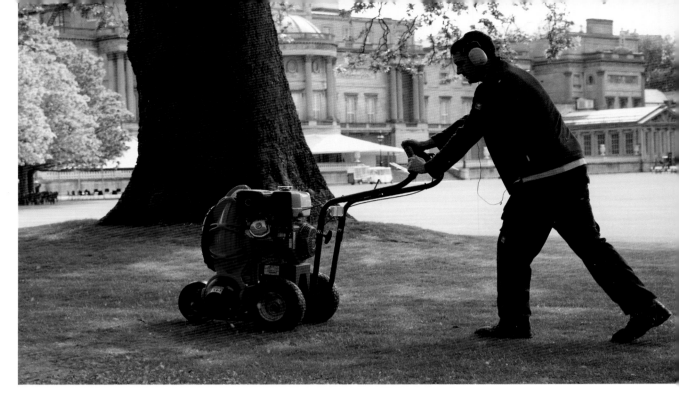

ABOVE *A gardener making the final preparations to the lawn on the morning of a garden party in 2015*

LEFT *The plaque commemorating a tree planted in honour of the birth of Prince Charles in 1948*

to the garden party season particular effort is put into showing the garden at its best. The huge lawn is mowed, fallen leaves blown and three miles of pathways carefully clipped. Trees are 'lifted', meaning that their lower branches are removed, to allow people in tall hats to walk easily underneath. Many trees in the garden have been planted to mark accessions, birthdays, anniversaries, jubilees and special visits. A pair of London plane trees was planted by Queen Victoria and Prince Albert and have branches that intertwine as a symbol of the couple's love. Many of these commemorative trees are marked with metal plaques at the base of their trunks and provide a source of fascination for garden party

Princess Elizabeth meeting guests during a garden party for repatriated Dominion prisoners of war in 1945

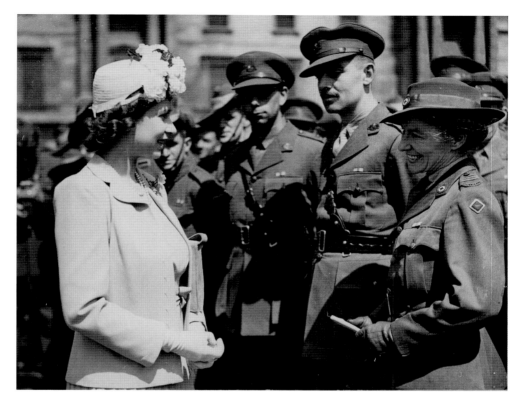

visitors. The herbaceous border running along the north edge of the lawn is over 150 metres long and six metres deep. Filled with herbaceous perennials in a tiered formation it provides continual colour from spring through to late autumn. The rose garden contains 25 beds, each with a different variety of rose, many of which have royal connections. The Royal William rose for example is a bright red rose planted in 1983 to commemorate the birth of The Duke of Cambridge.

In addition to the three garden parties held each year additional special garden parties are also sometimes held to celebrate anniversaries or to commemorate a particular group of people. On 24 May 1945 Princess Elizabeth attended an Empire Day Garden Party for 2,000 repatriated prisoners of war with her father and mother, King George VI and Queen Elizabeth. In 1997 The Queen and The Duke of Edinburgh invited 4,000 couples who were celebrating their golden wedding anniversary in the same year as the royal couple. In 2006 a special garden party was held to celebrate The Queen's 80th birthday. 2,000 children attended, chosen by national ballot,

My daughters and I had such a good time. We were so impressed with the friendliness of all the staff and officials, and with the warmth of the welcome we received. The organisation of the whole event worked brilliantly. The food was delicious and so attractively presented too.
2015 GARDEN PARTY GUEST

along with 80 costumed characters from children's books and television shows. Authors including J.K.Rowling and Raymond Briggs read from their books and signed autographs. In 2014 The Queen attended the annual garden party held for the Not Forgotten Association, a charity providing leisure and recreation events for serving and ex-service personnel with permanent injuries. For this event The Queen wore a dress decorated with a tulip pattern and matching yellow coat

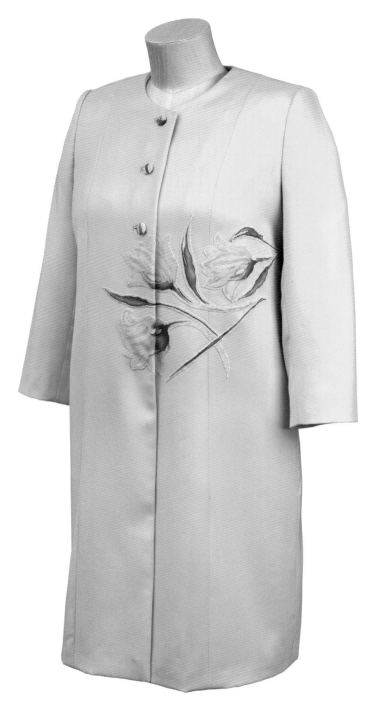

LEFT *Coat designed by Angela Kelly Couture*

ABOVE *Hat made by Rachel Trevor-Morgan*

decorated with an appliqué tulip of the same design. This outfit, which was designed by Angela Kelly Couture, was worn with a yellow hat decorated with brown and yellow flowers and feathers.

Garden parties take place from 4pm until 6pm, although the front gates open at 3pm for guests to start arriving. They are guided through the Grand Entrance and into the Bow Room, then out onto the terrace. A long marquee along the south side of the garden contains a buffet table laid with cakes and sandwiches, as well as tea, iced coffee and cordial. At each garden party around 27,000 cups of tea, 20,000 sandwiches and 20,000 slices of cake are consumed. Approximately 400 staff are on hand to serve the guests.

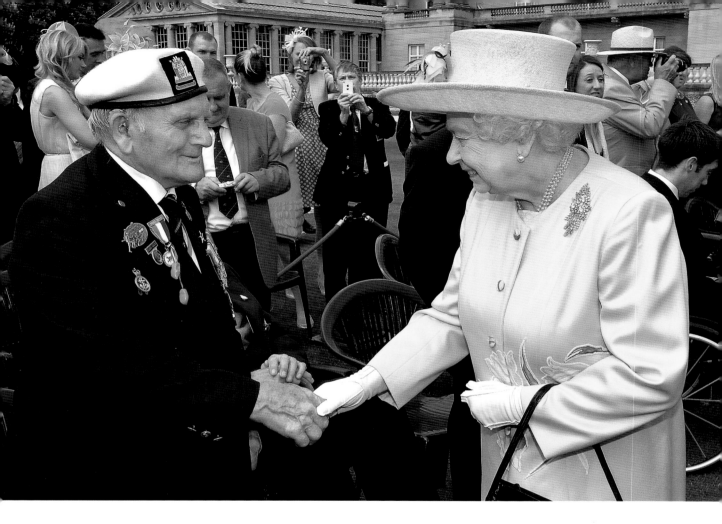

The event was so wonderfully organised and each and every member of your staff who we came into contact with, whatever their role in the day, were incredibly warm and personable and made us feel very welcome and very special. The event will stay with us in our memories, always.

2015 GARDEN PARTY GUEST

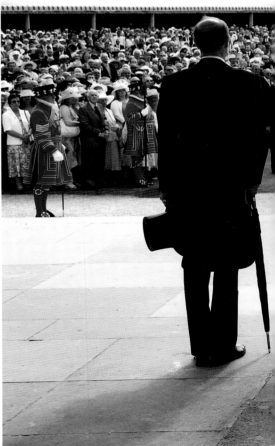

ABOVE *Household staff preparing the tea tent for a garden party*

RIGHT *The Queen and The Duke of Edinburgh with The Earl and Countess of Wessex arriving on the West Terrace during a garden party*

The arrival of the Royal party at 4pm on the West Terrace is indicated by one of the two military bands present playing the National Anthem. Several members of the Royal Family attend each garden party. The two corps of The Queen's personal Body Guard – the Yeomen of the Guard and the Gentlemen at Arms – are on duty throughout the afternoon. In anticipation of The Queen's arrival the crowd is organised into a series of lanes by the Yeomen. Gentlemen Ushers in morning coats, usually retired Armed Forces officers, are responsible for selecting

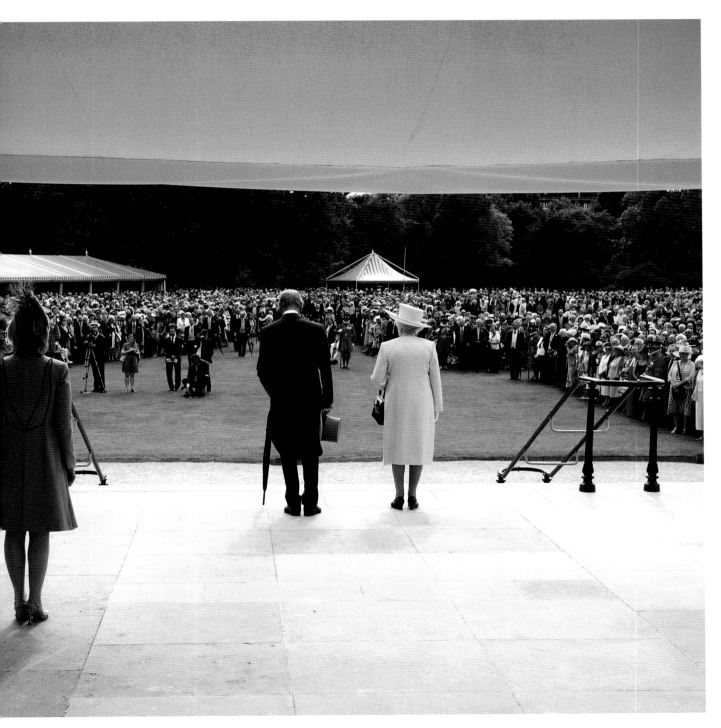

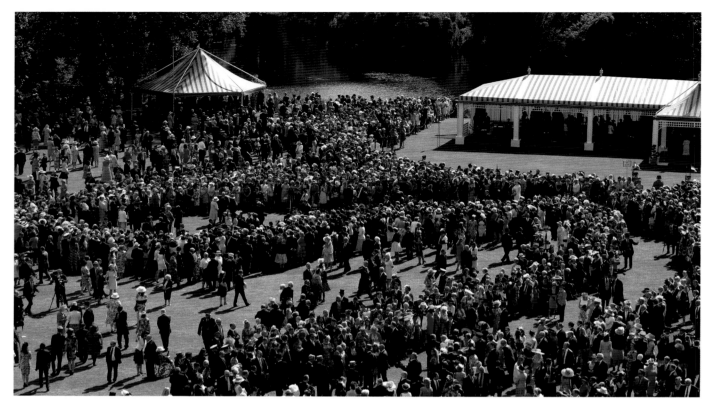

ABOVE *Guests at a garden party organised into lanes*

LEFT *The band playing at a garden party*

people to be introduced to The Queen and other members of the Royal Family, who gradually progress separately down the lanes meeting guests. The Royal party eventually reach the Royal tea tent, which is decorated with silver-gilt from the Grand Service, purchased by George IV. The bands continue to play alternately throughout the afternoon. The Royal party remain talking to guests in the Royal tea tent until returning to the palace at 6pm, when the National Anthem is played again.

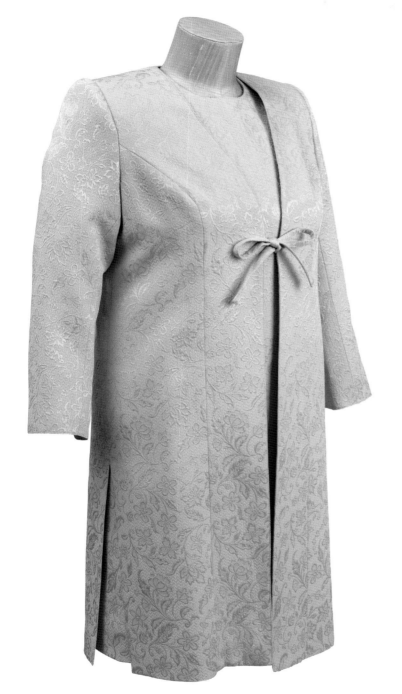

LEFT *Pale blue damask silk dress and coat designed by Stewart Parvin*

ABOVE *Hat designed by Philip Somerville*

BELOW *The Queen attending a garden party on 10th June 2014*

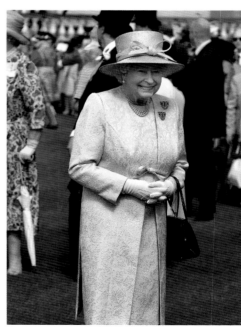

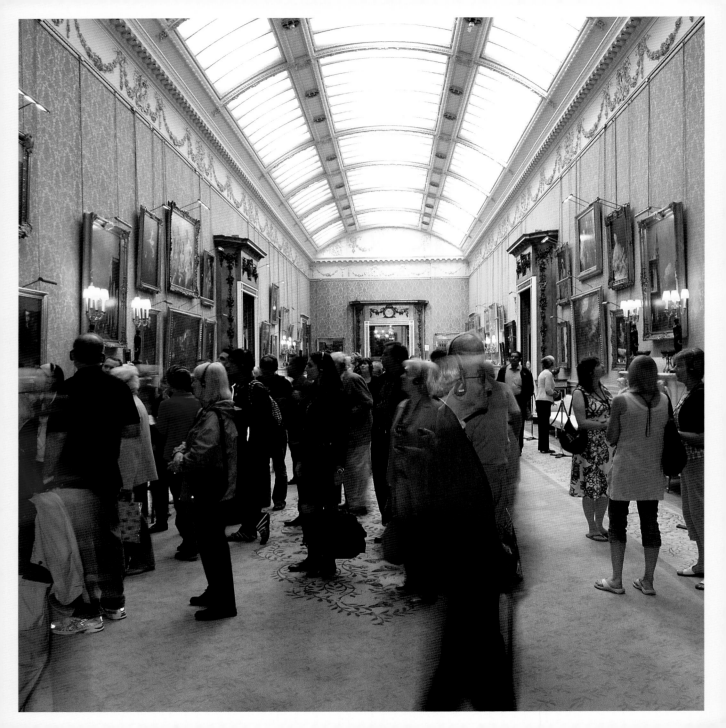

WELCOMING EVERYONE

IN 1992 A MAJOR fire broke out at Windsor Castle. In order to raise funds for the five year restoration programme that was required, Her Majesty decided to open Buckingham Palace to visitors while she is on her annual summer visit to Balmoral. Every year around 500,000 people visit Buckingham Palace during August and September. Now that the restoration of Windsor Castle is complete the income from visitors to the Palace is used to care for the Royal Collection and promote public access and enjoyment of the Collection through exhibitions, loans and educational activities. A key consideration for the staff working at Buckingham Palace is how to ensure that the paintings and works of art on display are cared for and maintained for future generations. The fact that the Palace is used so frequently for such a variety of functions presents particular challenges that are not applicable in a pure museum context. The upkeep of the Palace is the responsibility of the Property Section within the Royal Household, while the contents form part of the Royal Collection and are cared for by a team of curators and conservators. All Household staff working in the building and using the historic contents within it are fully trained in how to use them in order to best preserve them. The State Rooms are cleaned daily, with a team of housekeeping staff who start vacuuming, dusting and polishing at 6:30am each day. In advance of an occasion such as a State Visit, areas of gilding on walls and doors are retouched in gold. Smaller silver-gilt items used on the banquet table are stored

ABOVE *Members of the housekeeping staff dusting a candelabrum in the East Gallery and vacuuming the Picture Gallery*

OPPOSITE *Visitors in the Picture Gallery during the summer opening of Buckingham Palace*

ABOVE LEFT *Retouching a giltwood door*

ABOVE RIGHT *A member of the painting conservation team cleaning a painting*

in specially built rolling cases, with each drawer carefully labelled. Objects and paintings are routinely checked to ensure that they are safe from damage by atmospheric conditions. Paintings are hung in positions to ensure they will not be damaged by people or equipment during events, while being lit to best advantage. In addition large-scale conservation projects are sometimes undertaken when deemed necessary. A piano made by Sebastien Erard, which was purchased by Queen Victoria in 1856 was conserved in 2009 to remove layers of surface dirt, while replacing areas of lost

varnish and creating replacement pieces of carving for areas of loss on the carved legs. It is covered with gold leaf and painted decoration. After a year in the conservation studio the piano is now back on display in the White Drawing Room. Paintings too are subject to conservation treatment when necessary. Layers of overpaint and discoloured varnish are carefully removed by a team of conservators based at Windsor Castle, whose remit is to care for the paintings and as far as possible ensure they are seen in the state intended by the original artist.

From the gilt-edged and gold-crested invitations, to the warm and personal welcome by liveried footmen, from the careful selection of food, drink and music, to the magnificent surroundings and masterpieces hanging on the walls, a royal welcome to Buckingham Palace guarantees that every single one of the 62,000 invited guests receives an unsurpassed level of hospitality and an unforgettable experience.

Many of the objects presented in this publication form part of the Royal Collection, one of the largest and most important art collections in the world, and one of the last great European royal collections to remain intact.

Discover more about the Royal Collection at **www.royalcollection.org.uk**

ABOVE *A grand piano made by Erard in 1856 being retuned after conservation in 2009*

OVERLEAF *The White Drawing Room showing the newly conserved piano in position (bottom right)*

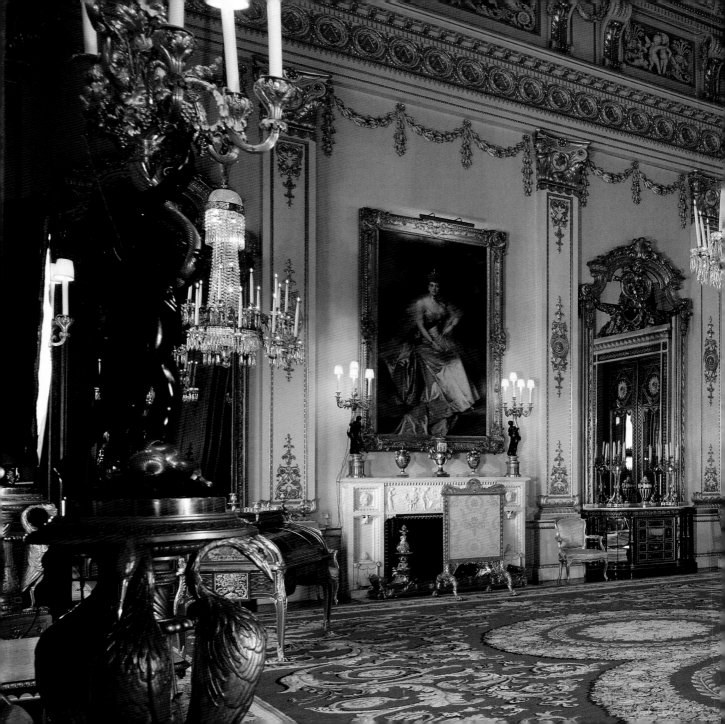

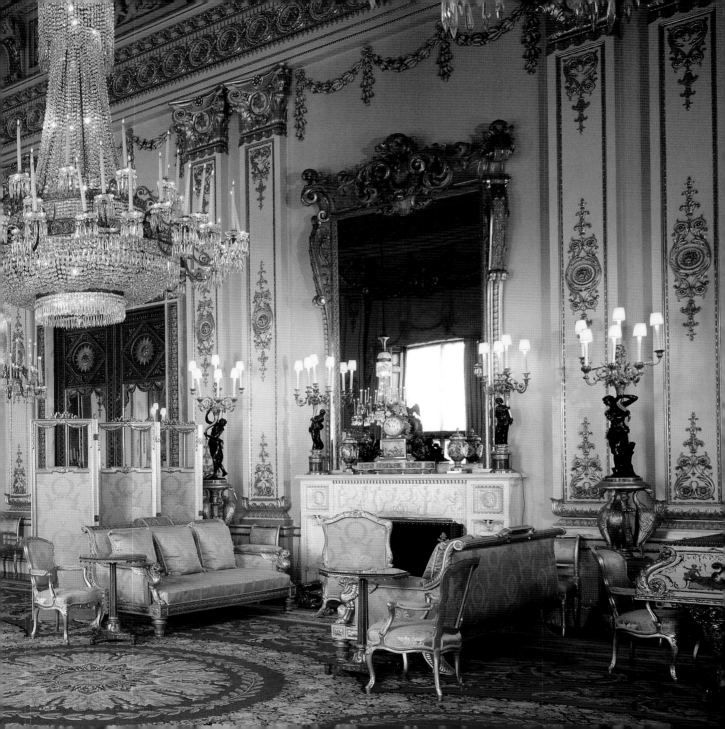

PICTURE CREDITS

ACKNOWLEDGEMENTS

The author would like to acknowledge the support and gracious permission of Her Majesty The Queen for the undertaking of this exhibition at Buckingham Palace and the publication of this book.

A Royal Welcome has relied heavily on the co-operation of numerous members of the Royal Household each of whom has been extremely generous with their time and unerringly patient with our requests for filming, photography and information. Particular thanks are due to Anne Barton, Andrew Basson, Toby Browne, Michael Brooks, Lisa Carlman, James Chin, Kathryn Cuthbertson, Tim Doncaster, Jackie Fergusson, Mark Flanagan, Edward Griffiths, Michael Jephson, Tony Johnstone-Burt, Lizzie Keay, Angela Kelly, Mark Lane, Robert Large, Nigel McEvoy, Stephen Marshall, Oscar Matthews, Stella McLaren, Stephen Murray, Jackie Newbold, Mathew Palser, David Pogson, Andrew Richardson, James Roscoe, Michael Taylor, Richard Thompson, Sarah Townend, Michael Vernon, Rachel Wells and Ray Wheaton.

This project and exhibition would not have been possible without the support of colleagues in Royal Collection Trust. I gratefully acknowledge the assistance of Sandra Adler, Julia Bagguley Allison Derrett, Tamsin Douglas, Caroline de Guitaut, Roxanna Hackett, Stephanie Howard, Kathryn Jones, Richard Knowles, Hannah Lake, Kevin Lane, Karen Lawson, Susanna Mann, Jonathan Marsden, Theresa-Mary Morton, Alessandro Nasini, Daniel Partridge, Shruti Patel, Stephen Patterson, Tung Tsin Lam, Sophy Wills, Rhian Wong, Rachel Woollen and Eva Zielinska-Millar. For their expertise on preparing the clothing and mannequins thanks go to Deborah Phipps, Ashley Backhouse and Sam Hoye.

For the film footage and stills, thanks to David Bickerstaff and Beverley Garrett at New Angle.

For the exhibition design thanks to Alan Farlie and Louisa Turner at RFK Architects.

Finally the author would like to thank the publishing team, in particular Elizabeth Simpson, Peter Dawson and Debbie Wayment.

To find out more about the Royal Collection please visit our website
www.royalcollection.org.uk

Written by Anna Reynolds

Published 2015 by Royal Collection Trust
York House
St James's Palace
London SW1A 1BQ

ISBN 978 1 909741 25 6
100126

British Library Cataloguing in Publication Data:
A catalogue record of this book is available from the British Library.

Designed by Grade Design
Production Manager Debbie Wayment
Project Manager Elizabeth Simpson
Edited by Magda Nakassis and Sophie Kullman
Colour reproduction by Altaimage
Typeset in Adobe Garamond Pro
Printed on Gardmat 150gsm
Printed and bound in Slovenia by Gorenjski tisk